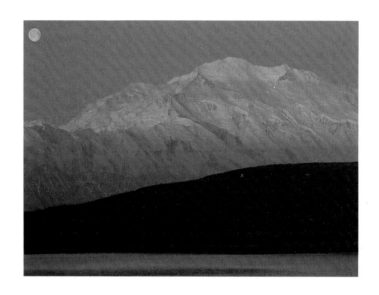

ALASKA

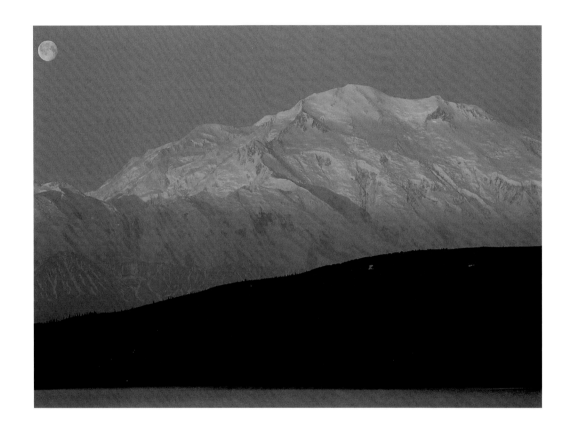

WHITECAP BOOKS

Text by Tanya Lloyd
Edited by Elaine Jones
Photo editing by Tanya Lloyd
Proofread by Lisa Collins
Cover and interior design by Steve Penner
Desktop publishing by Susan Greenshields
Printed and bound in Canada

National Library of Canada Cataloguing in Publication Data

Lloyd, Tanya, 1973–

 Alaska

 ISBN 1-55285-025-0

1. Alaska—Pictorial works. I. Title.
F905.L56 2000 979.8'052'0222 C00-910063-6

The publisher acknowledges the support of the Canada Council and the Cultural
Services Branch of the Government of British Columbia in making this publication
possible. We acknowledge the financial support of the Government of Canada through
the Book Publishing Industry Development Program for our publishing activities.

For more information on the America Series and other Whitecap Books
titles, please visit our web site at www.whitecap.ca.

Thousands of years ago, native people arrived in Alaska, traveling over a bridge of ice that linked North America with Siberia during the last ice age. Since then, people have lived and hunted on the Alaskan tundra, in the sprawling forests and mountain ranges that cover the interior, and along the rugged coastline of the Inside Passage. Russian explorers landed on the western shores, forging settlements and trading routes. Whaling ships plied the waters of the Bering Sea and the Pacific Ocean, and British, Spanish, and American explorers charted the land. Prospectors and adventurers arrived to challenge the rivers.

These diverse groups of people have now inhabited Alaska for centuries. Yet none has managed to mark this vast region. The effects of human population, from abandoned gold mines and elite fishing lodges to weather stations and railways, have changed less than 1/20 of 1 percent of the land. Large developments such as the Trans-Alaska Pipeline are only minuscule scratches when compared to the expanse of the Arctic plains, the height of Mount Denali, or the winding length of the Yukon River.

Alaska stretches more than 1,420 miles from the Arctic Ocean south to the Pacific and over 2,400 miles east from the Bering Sea to the border with Canada. It is the largest state in America, almost 500 times larger than Rhode Island. America's second largest state, Texas, is less than half its size. In fact, at 570,374 square miles, Alaska accounts for about 20 percent of the entire surface area of the lower 48 states.

Those who visit or live here are drawn by the state's natural resources. To some, this means lumber, ore, and oil. When oil was discovered in Prudhoe Bay in 1968, it developed into the nation's largest fields, accounting for 25 percent of U.S. oil production. To others, Alaska's natural riches lie in its dramatic landscapes and abundant wildlife. Caribou, wolves, grizzlies, black bears, and humpback whales have thousands of untouched miles to roam—along with a few adventurous travelers.

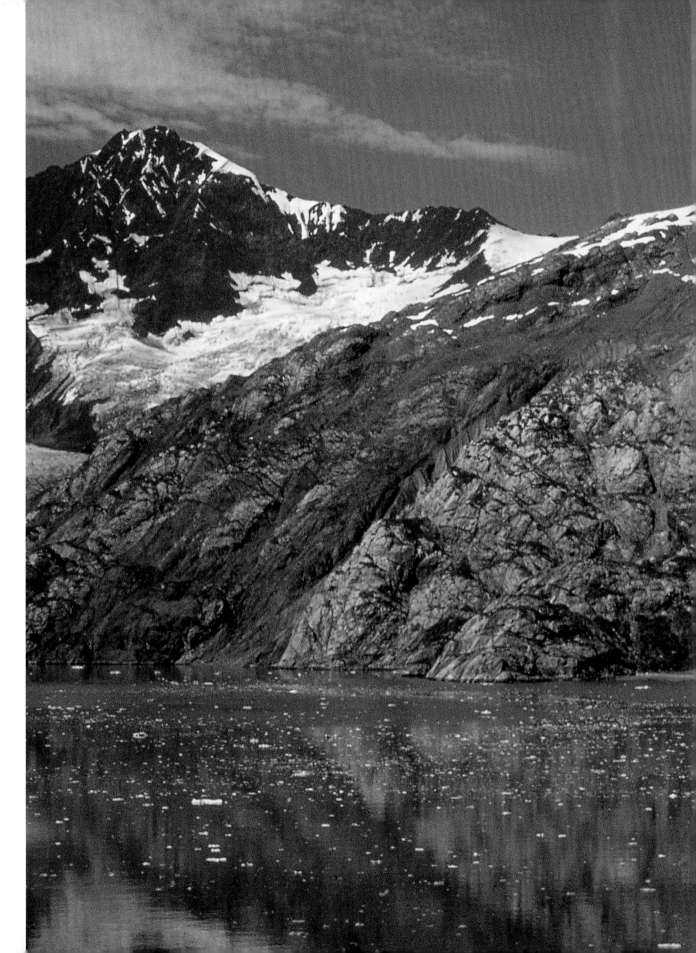

Hundreds of thousands of visitors cruise to Alaska each year. Some choose short journeys through the Inside Passage to Ketchikan, while others journey all the way to the Bering Strait, sometimes even stopping in Russia.

6

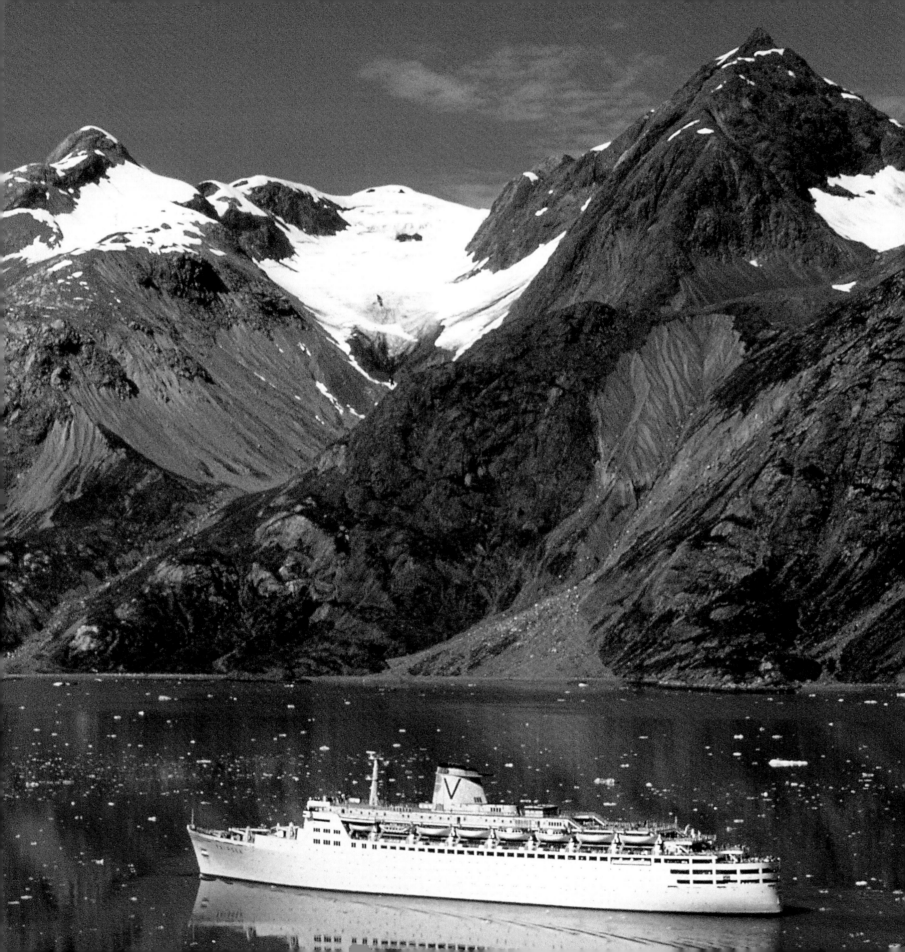

Passengers on a small expedition ship keep a close watch on the waters of the Inside Passage, looking for signs of marine life. Seals can often be spotted, along with porpoises, dolphins, and whales.

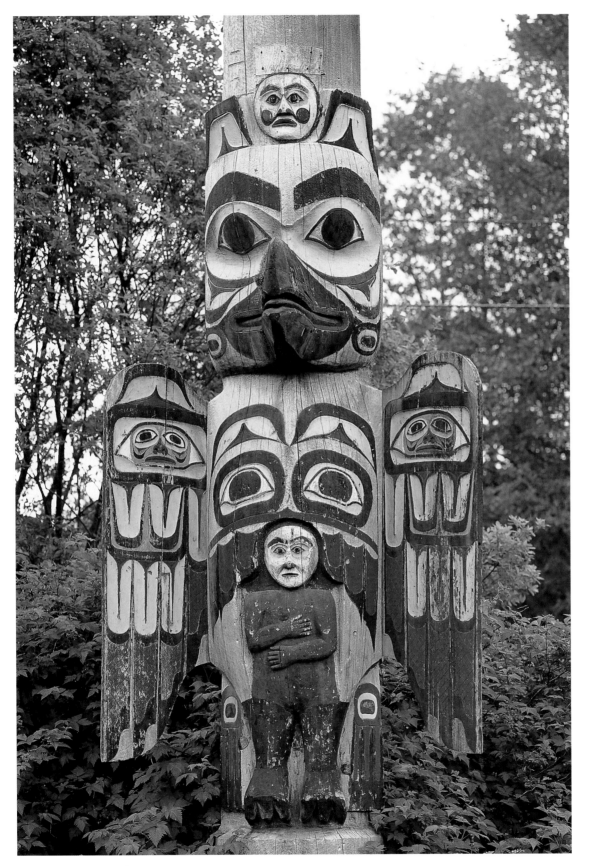

Ketchikan boasts more totem poles than anywhere else in the world and local artisans continue to carve new additions. Some of the most remarkable stand in Saxman Totem Park, where poles from the ancestral villages of Cape Fox, Tongass Island, Cat Island, and Pennock Island are now on display.

Once a red-light district of bars and brothels, Ketchikan's Creek Street is now a favorite stop for cruise ship passengers. Dolly's House, home of the town's most famous madam, has been preserved as a museum.

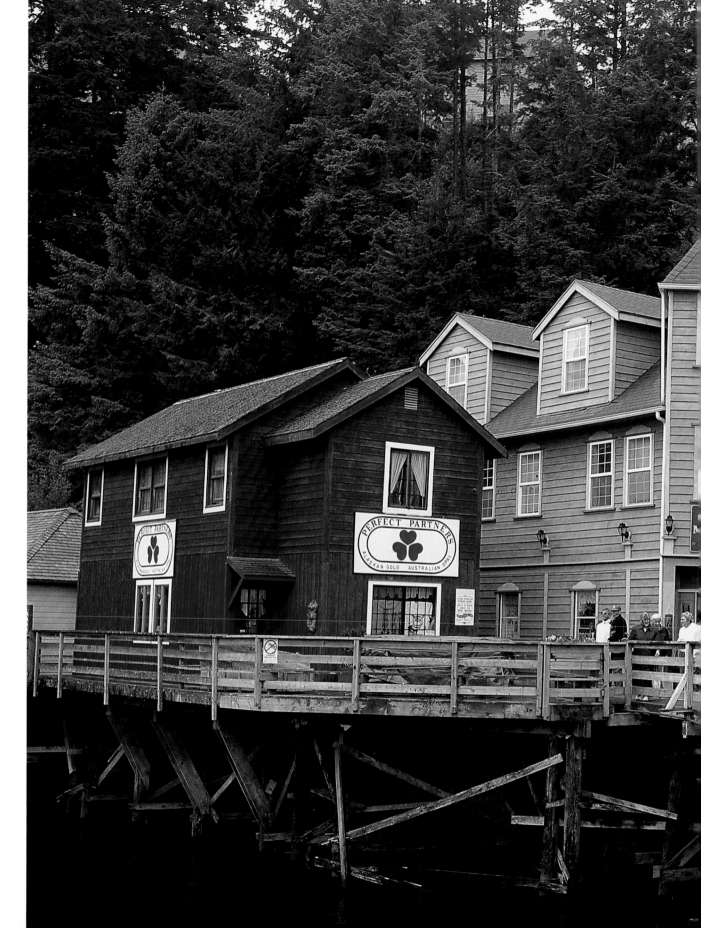

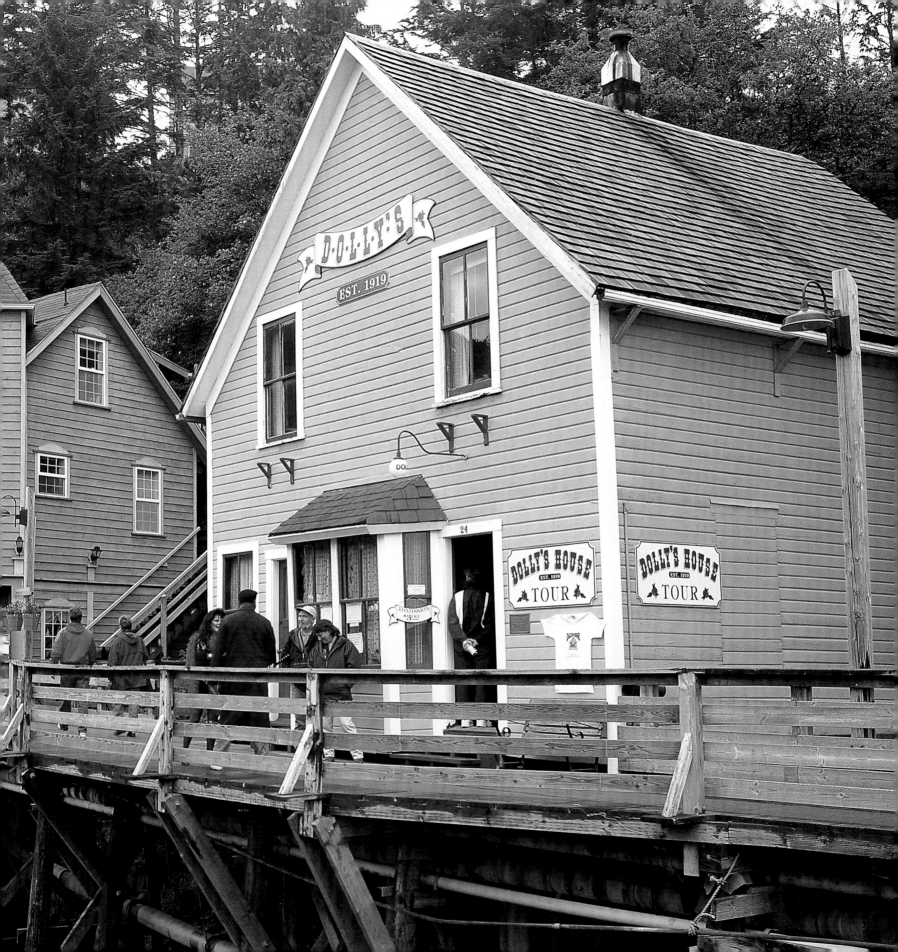

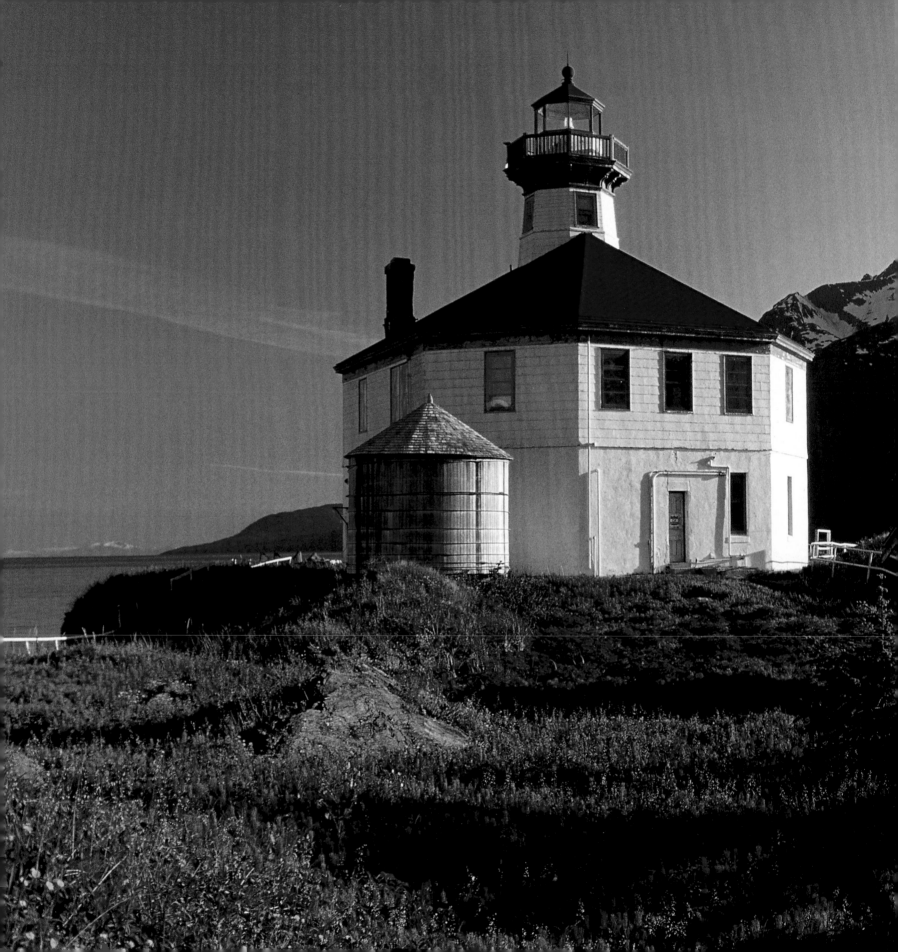

A historic lighthouse sends its beacon sweeping over the waters of Lynn Canal. This long, forked waterway was the route many fortune-seekers chose on their way to the gold fields of the Klondike in the late 1800s.

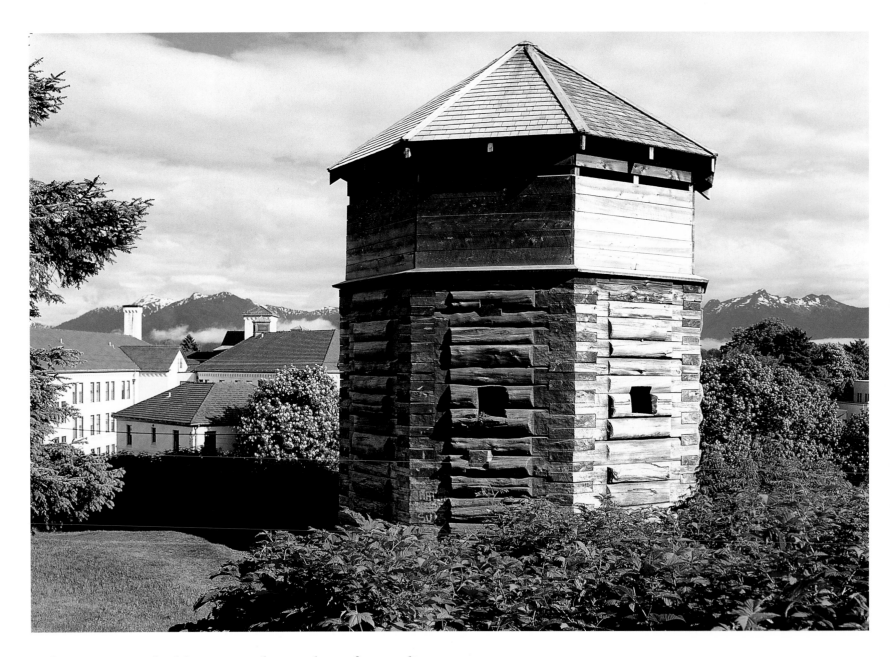

Sitka's Russian Blockhouse is a log replica of an earlier structure,
one that separated the new Russian settlement from homes of the
Tlingit people. From this outpost, Russians shipped furs and ice as
far away as San Francisco.

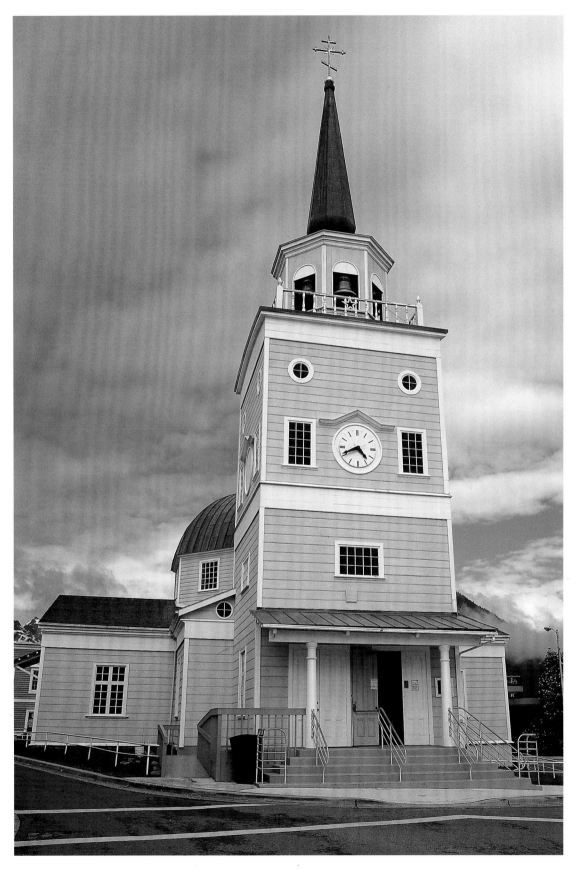

Fire destroyed the original St. Michael's Cathedral in Sitka in 1966, but a faithful replica was rebuilt a decade later, complete with icons and artwork saved from the flames.

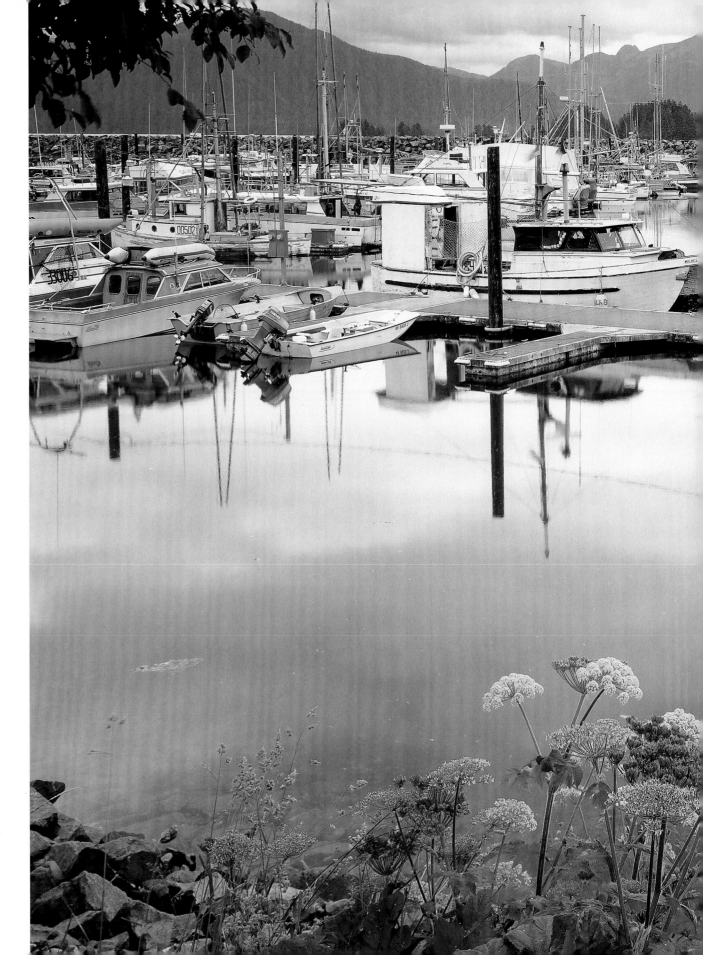

In the early 1800s, Sitka was an important trading base for the native Tlingit people and new arrivals from Russia. When the United States gained control of Alaska in 1867, this became the state capital and remained so until 1906.

16

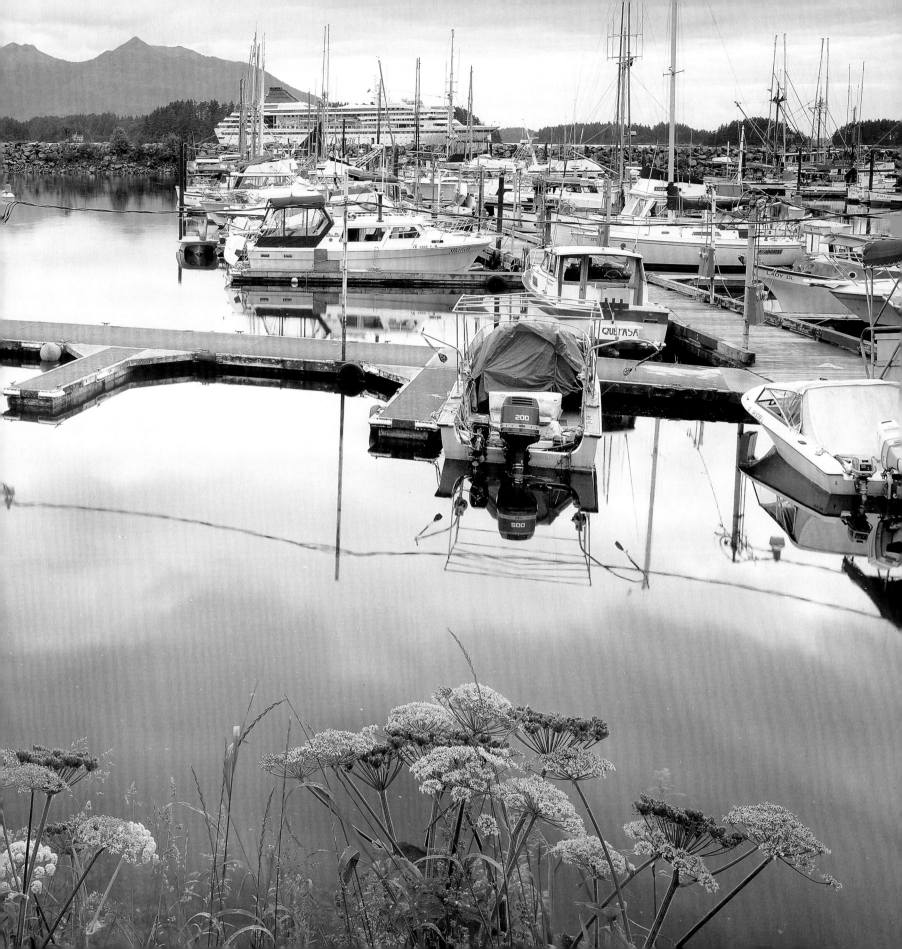

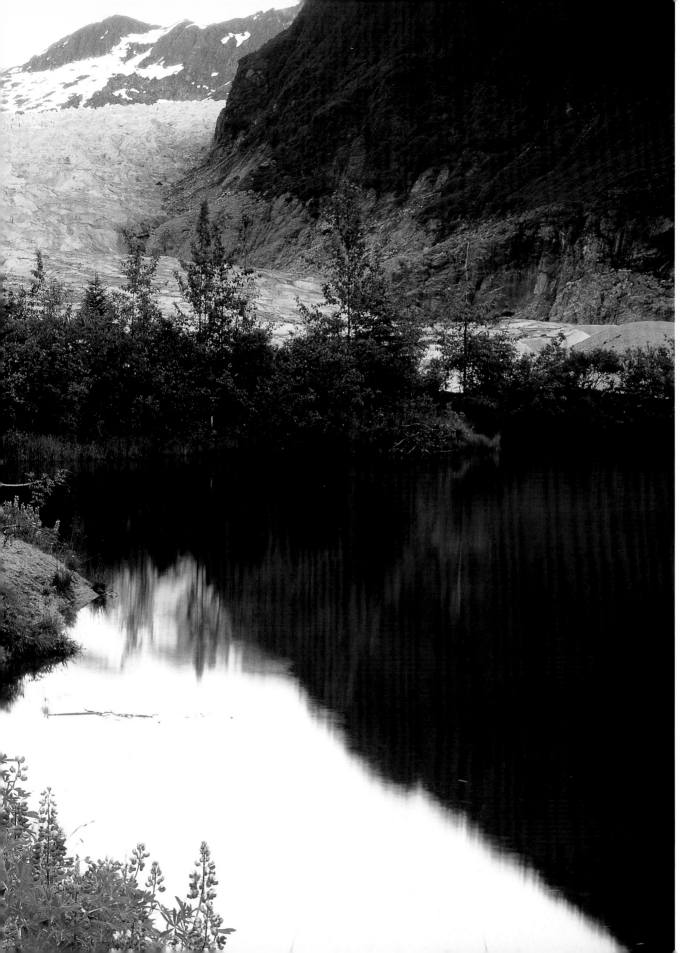

Extending for 17 million acres, Tongass National Forest—the largest in America—is home to towering Sitka spruce, hemlock, and cedar. Almost one-third of the world's remaining old-growth temperate rainforest exists within this region.

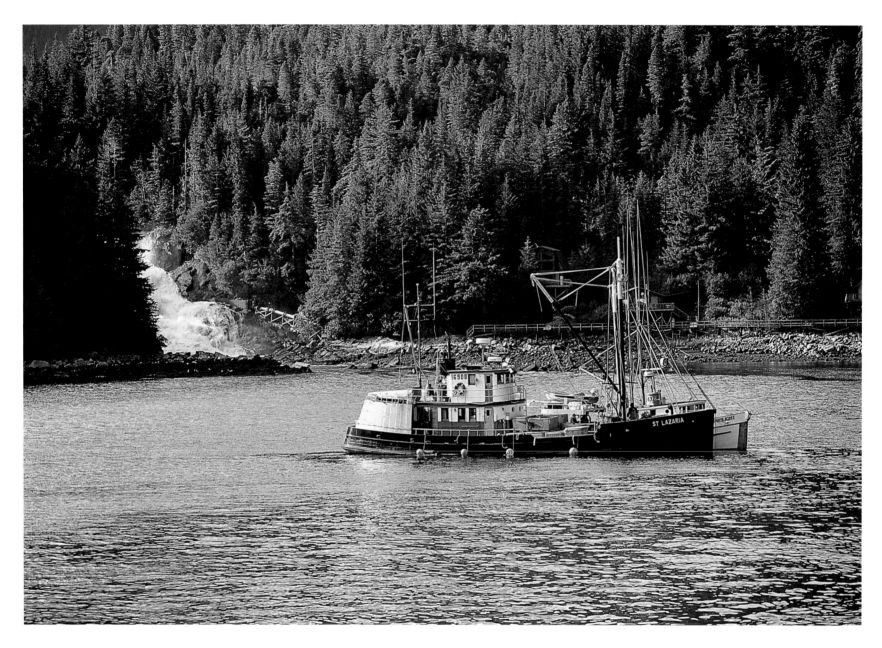

Fishing is one of the state's largest industries, second only to oil.
Though the fisheries have declined in recent years, fleets continue
to produce almost half the total amount of seafood landed in the
entire country, including the world's largest catch of wild salmon.

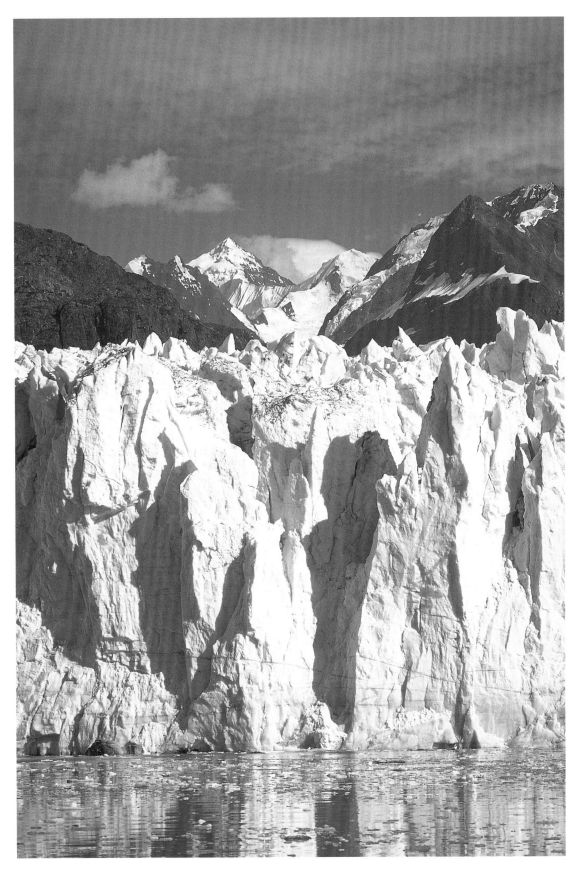

Sixteen glaciers pour meltwater and calve huge chunks of ice into the waters of Glacier Bay National Park. So much ice breaks off some glacier walls that even large ships stay several miles away.

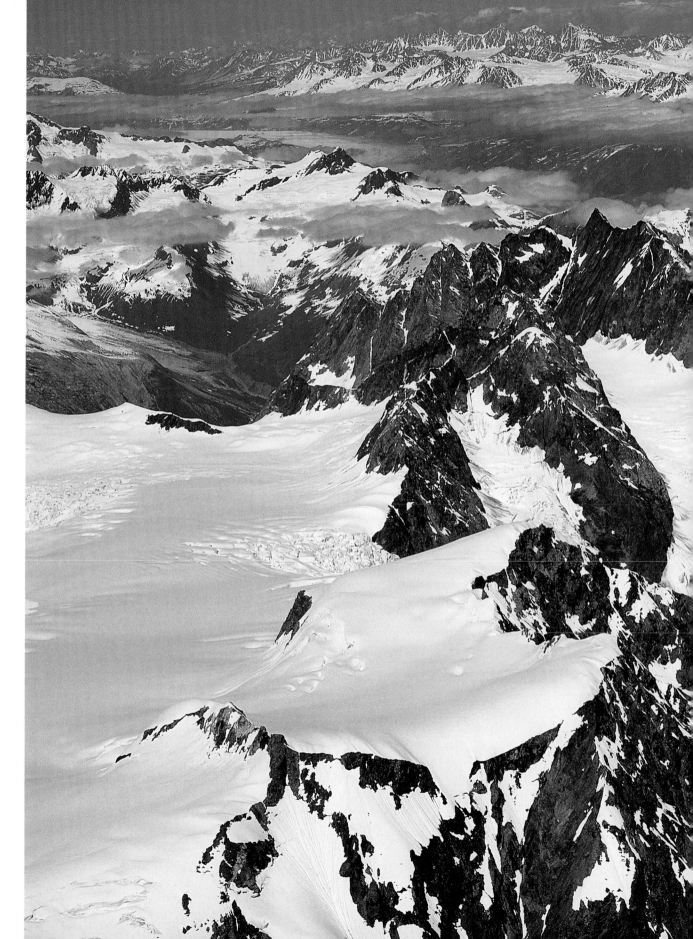

When explorer
George Vancouver
sailed through this
area in 1794, Glacier
Bay was not a bay
at all—it was filled
with ice. By the late
1800s, the glaciers
had receded nearly
40 miles, and today
the bay is more than
60 miles deep.

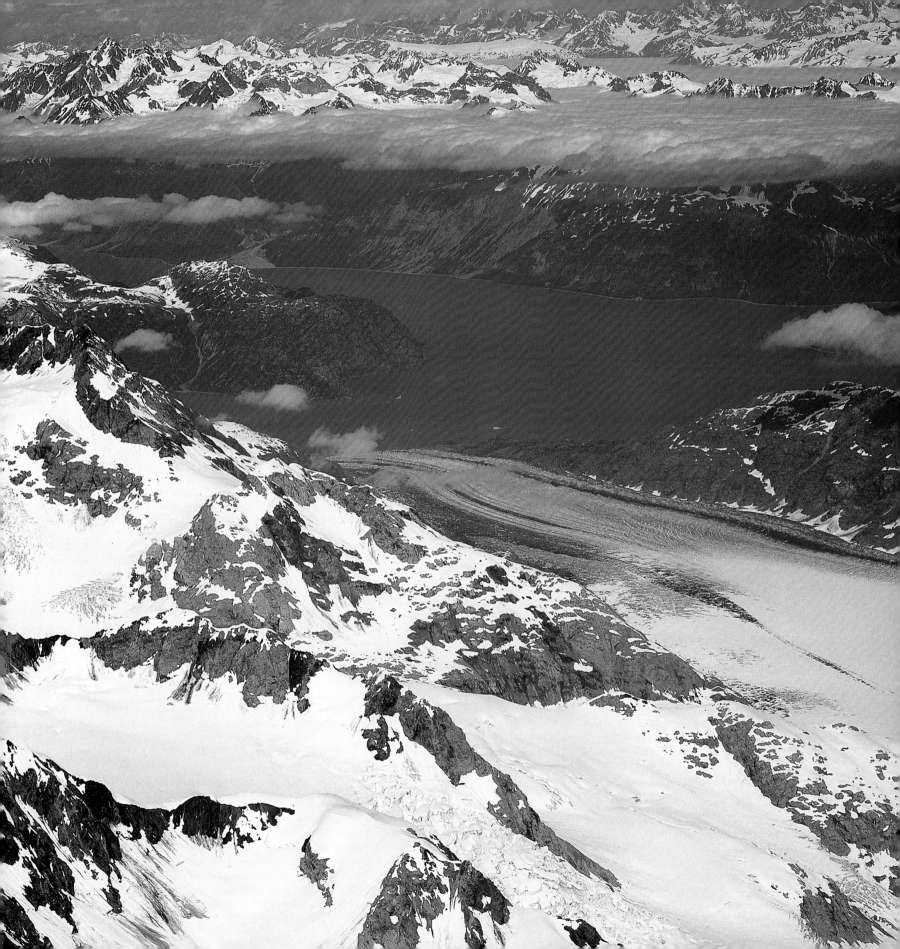

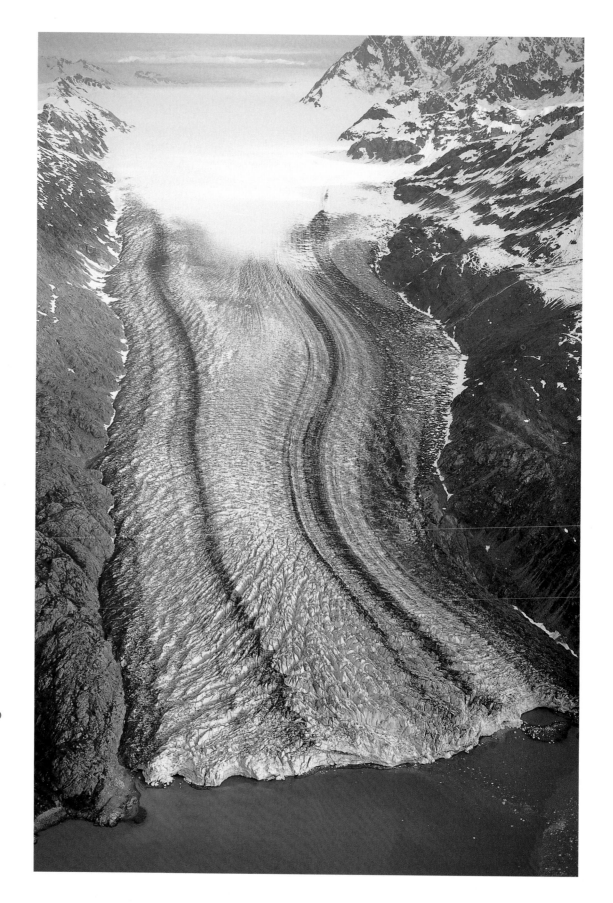

More than 400,000 visitors arrive in Glacier Bay National Park each year, to view just a few of Alaska's massive iceflows. More than half the glaciers in the world can be found within the state.

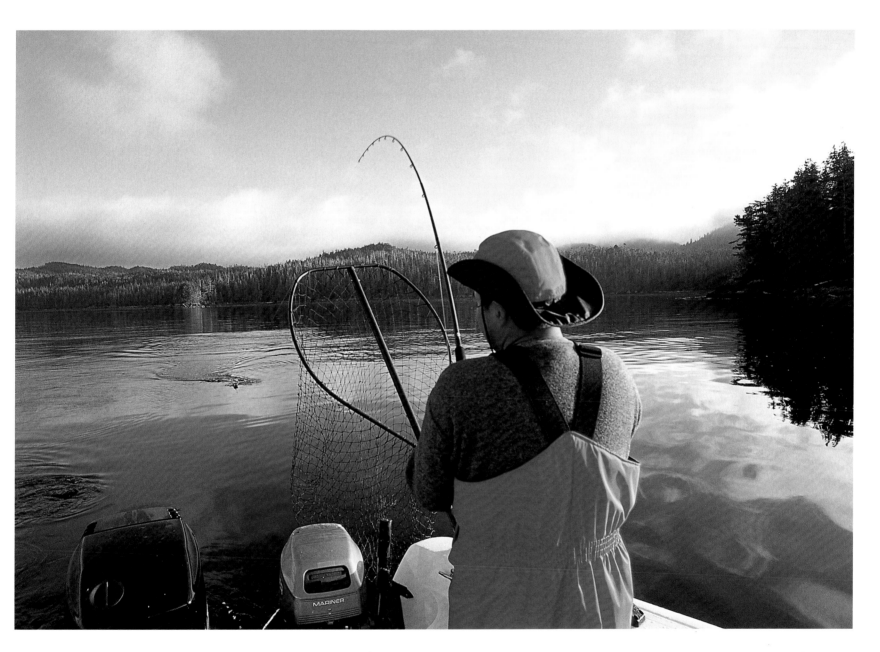

A fisherman reels in his catch on one of Alaska's many charter fishing boats. Sockeye, chinook, pink, coho, and chum salmon are sought-after trophies along the Inside Passage.

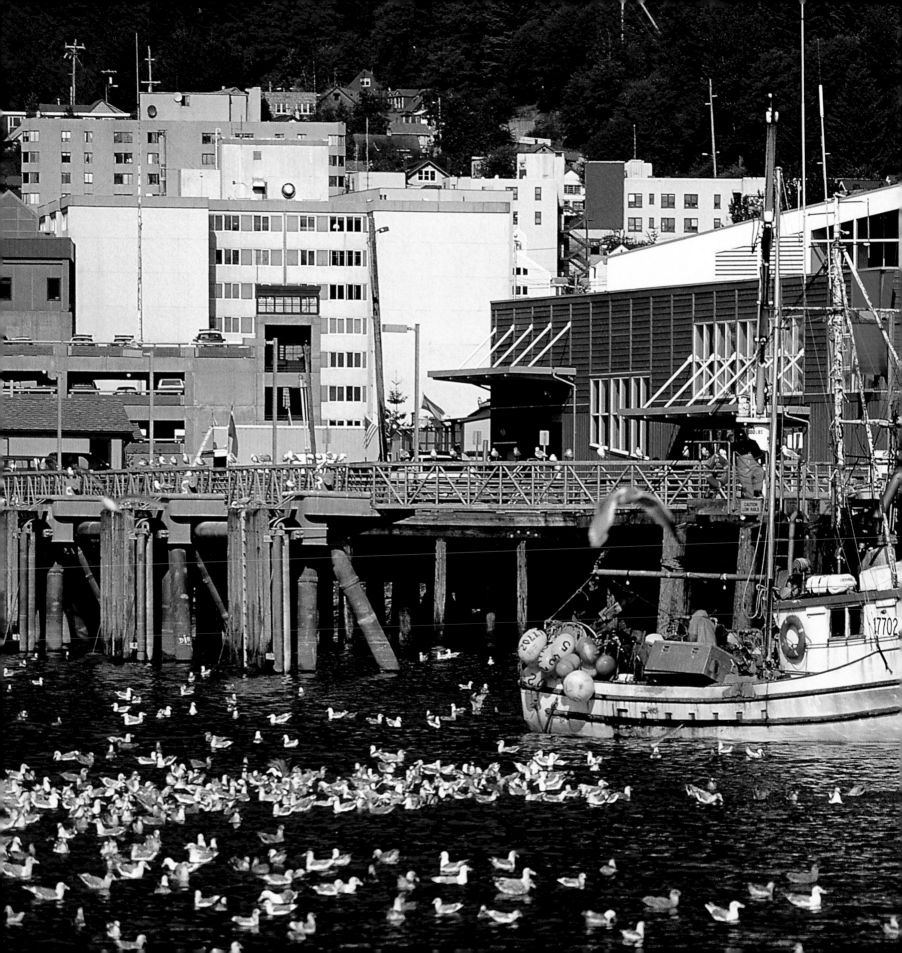

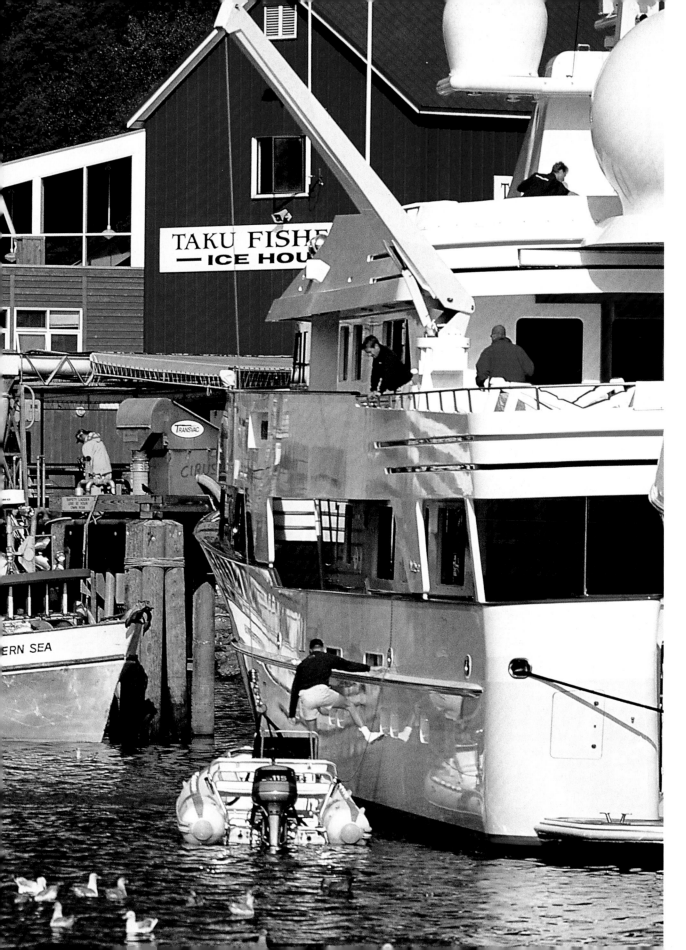

At one time, there were 14 canneries in Juneau. And though the fishing industry has declined, local vessels still crowd the docks to sell catches of fresh halibut and salmon.

Juneau is the only capital city in America that can't be reached by road. The city was founded in 1880 when Tlingit chief Kowee led prospectors Joe Juneau and Dick Harris to the mineral-rich area.

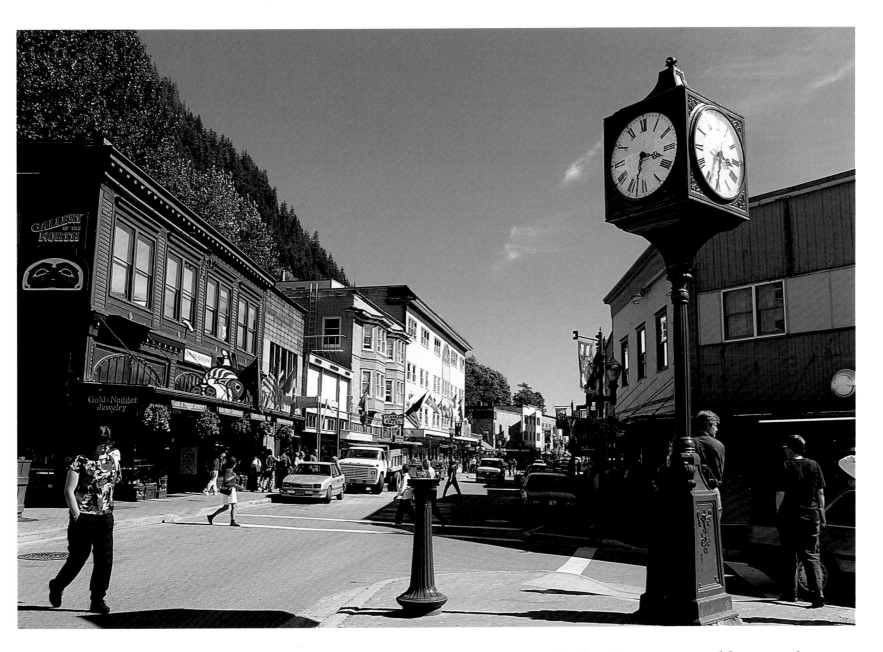

Because visitors to Juneau arrive by air or water and because the steep streets are most easily walked, there is little traffic in the city. In fact, there are less than a dozen traffic lights.

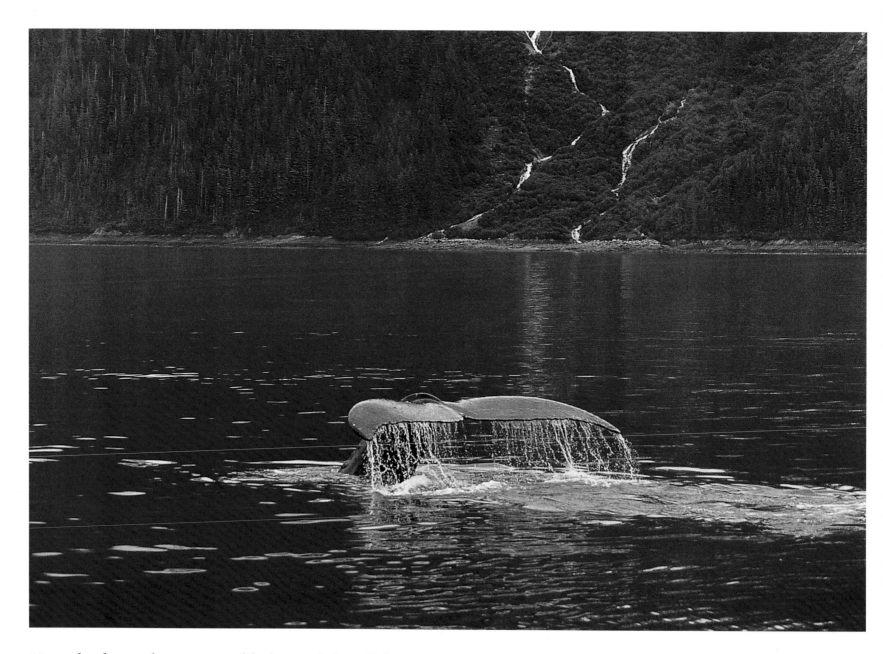

Humpback, minke, orca, and beluga whales all frequent the waters off the shores of Alaska. Humpbacks are the most common and the most acrobatic of these creatures, breaching and slapping their tails on the surface.

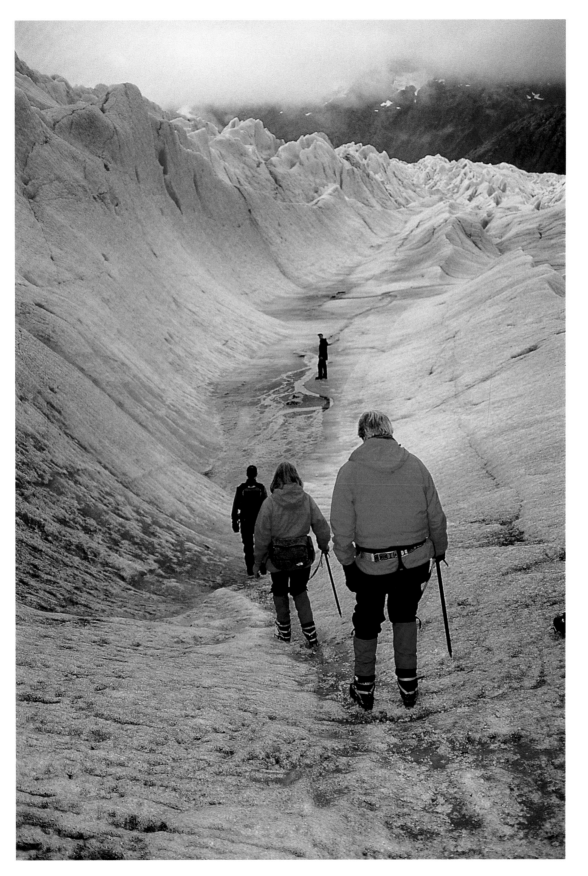

Helicopters whisk visitors high above Juneau to clamber on the ice of the Mendenhall Glacier. This is one of the most visited glaciers in the state.

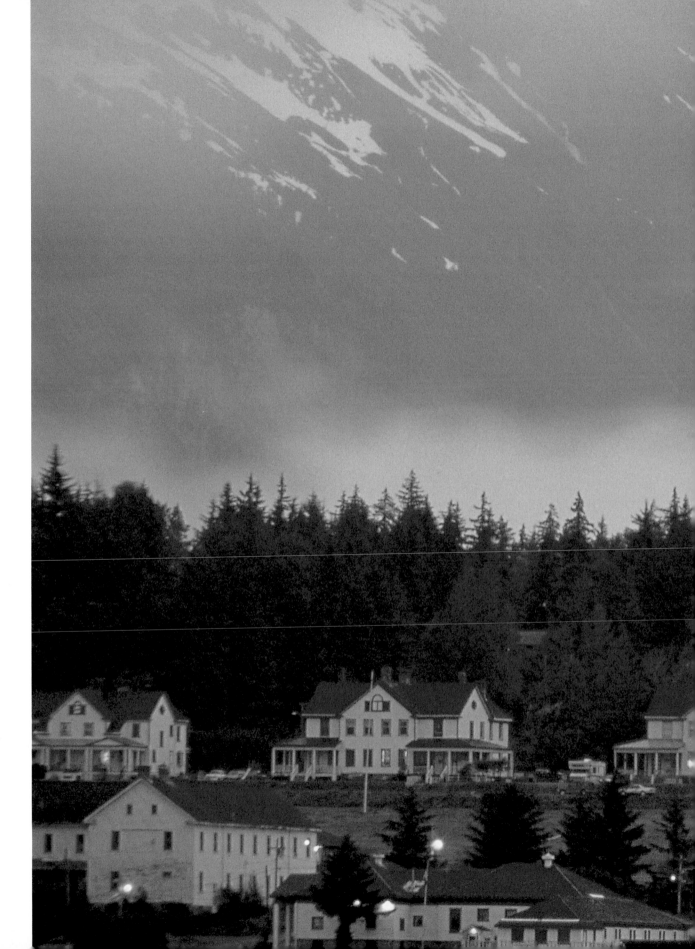

Founded as a missionary outpost, Haines became a gateway to the Klondike Gold Rush in the 1890s. Today, it is a popular base for hiking and river-rafting expeditions.

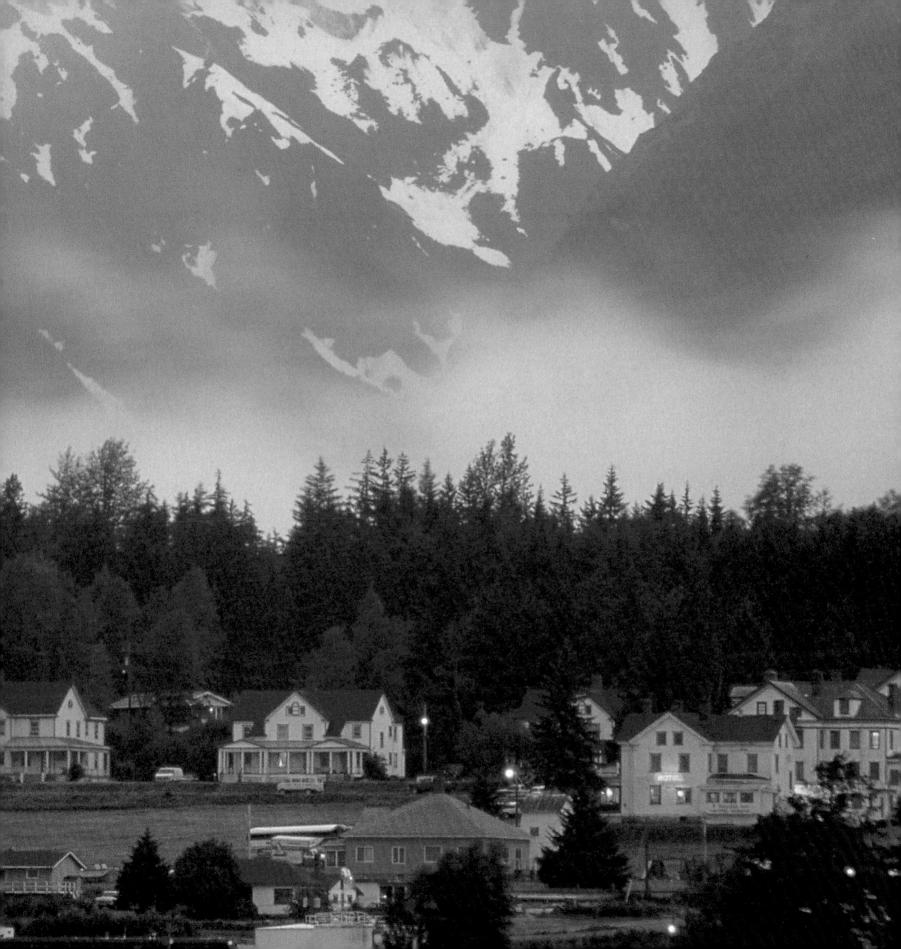

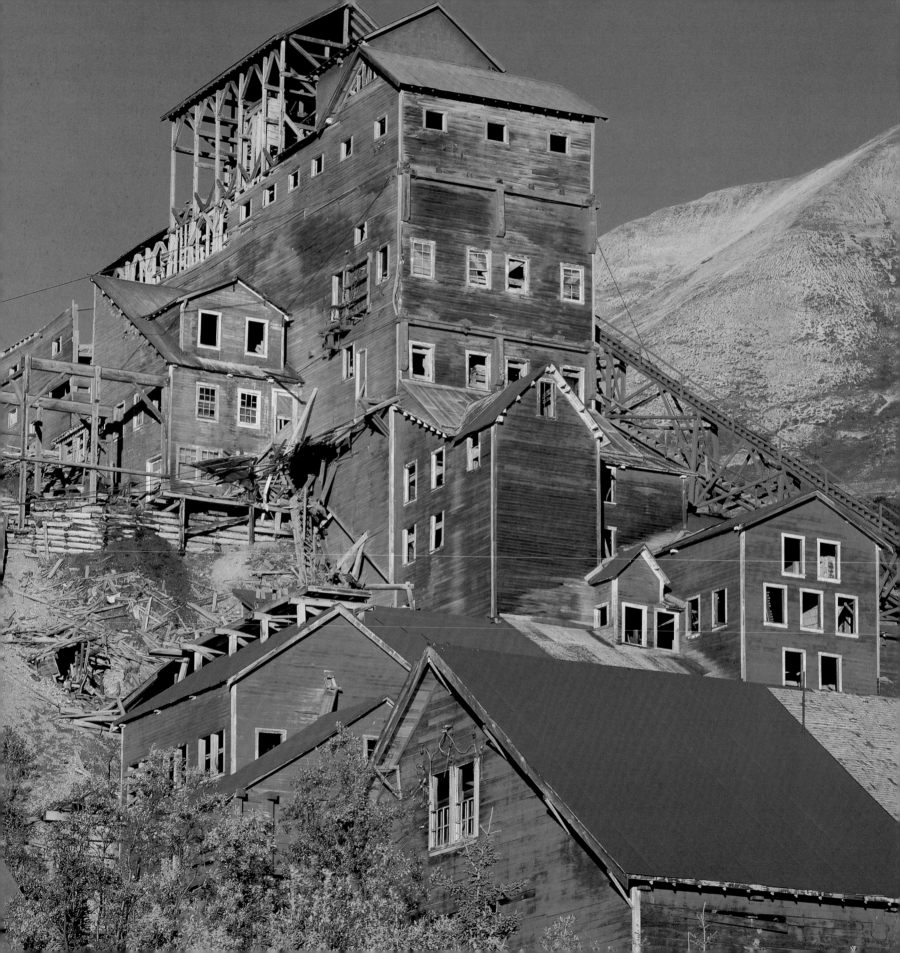

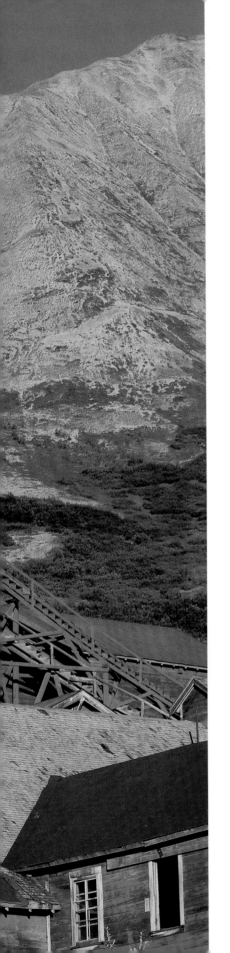

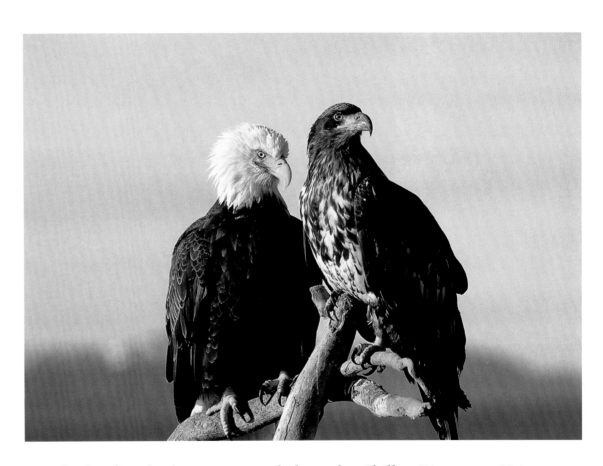

Hundreds of eagles live year-round along the Chilkat River near Haines and about 3,000 line the riverbanks each fall, when a late run of spawning salmon provides a rich and abundant food source.

The Kennecott Copper Mine produced ore worth more than $200 million in the early 20th century. In these misshapen buildings, the copper was crushed and sifted before being loaded onto trains along the Northwestern Railway.

The largest national park in the nation, Wrangell-St. Elias is part of a UNESCO World Heritage Site. The 13,188,000 acres protected by the preserve are bordered by Kluane National Park in Canada's Yukon Territory. It provides a vast habitat for grizzlies, Dall sheep, and an array of other wildlife species.

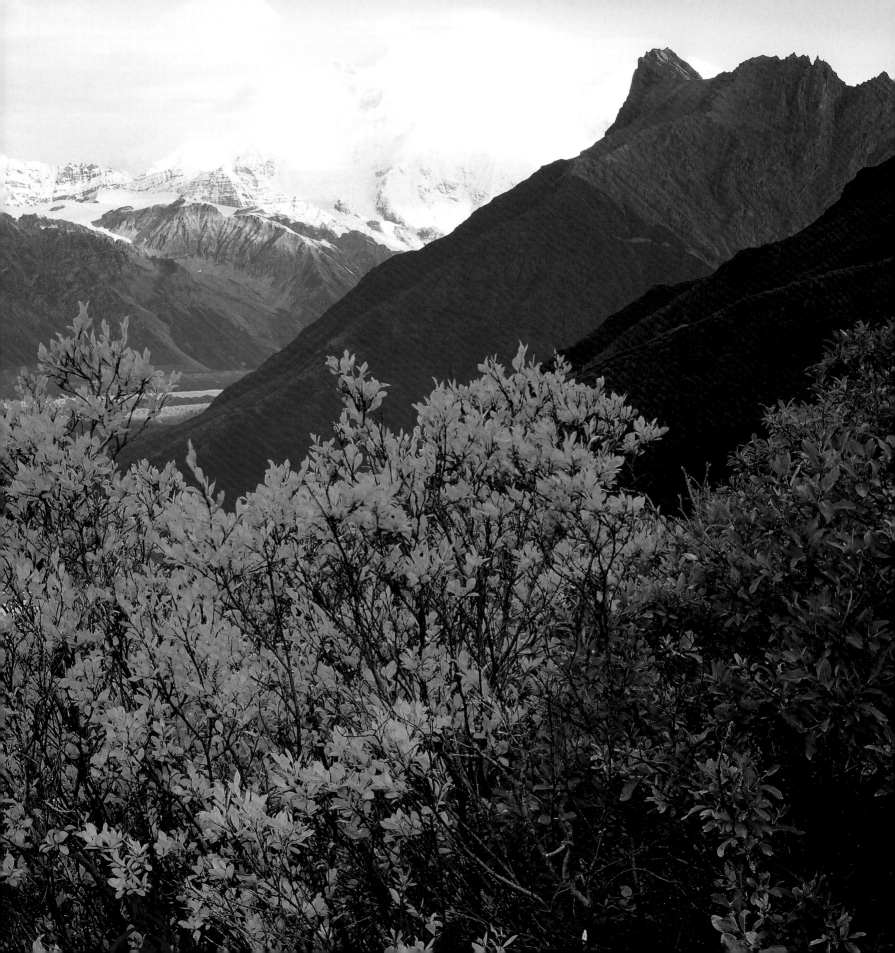

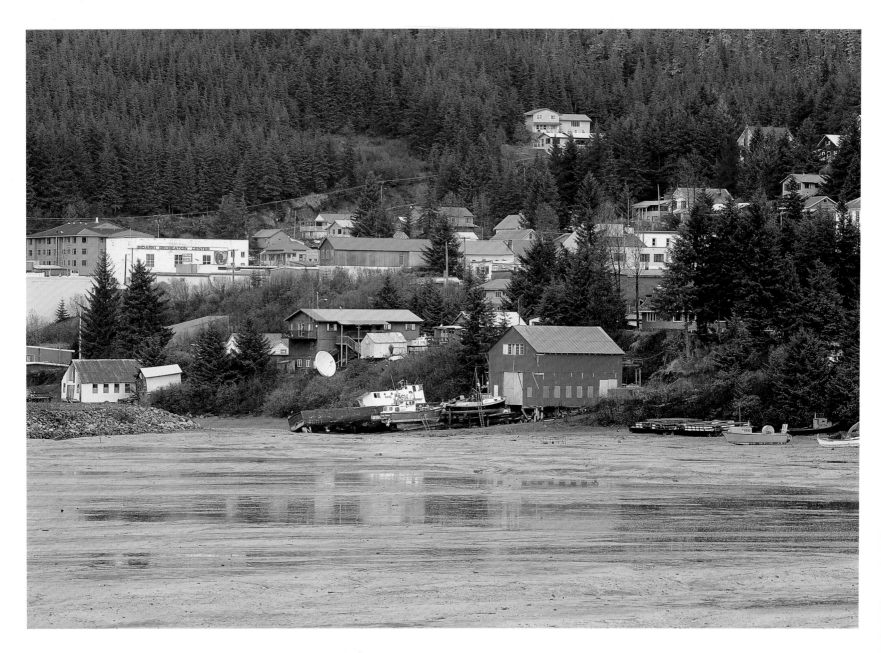

More than half a century ago, trains carried ore from the Kennecott Copper Mine (now part of Wrangell-St. Elias National Park and Preserve) to the port of Cordova. Today, Cordova is a commercial fishing base.

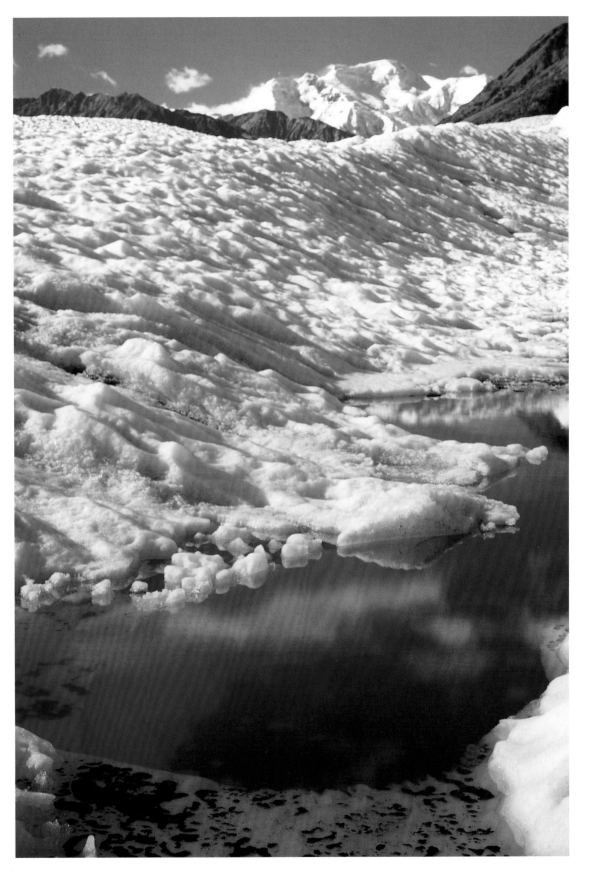

More than 100 glaciers, some larger than Rhode Island, cascade from the peaks of Wrangell-St. Elias National Park and Preserve. Nine of the 16 highest peaks in the country are found here.

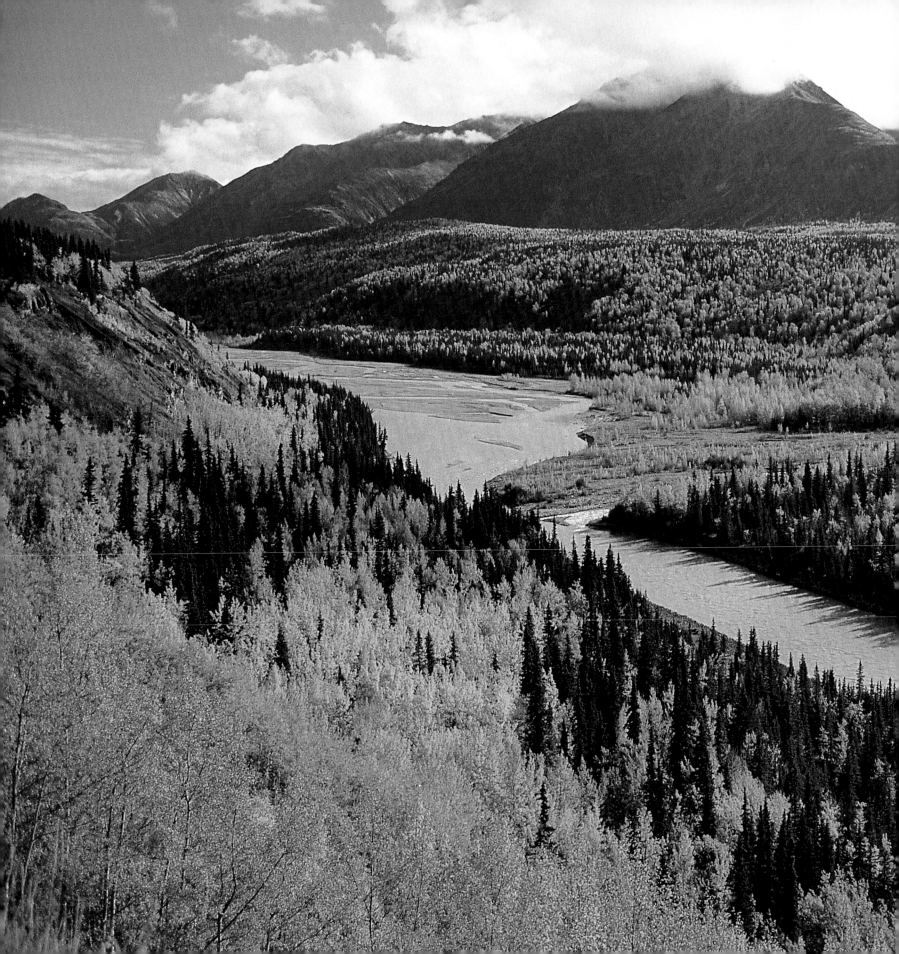

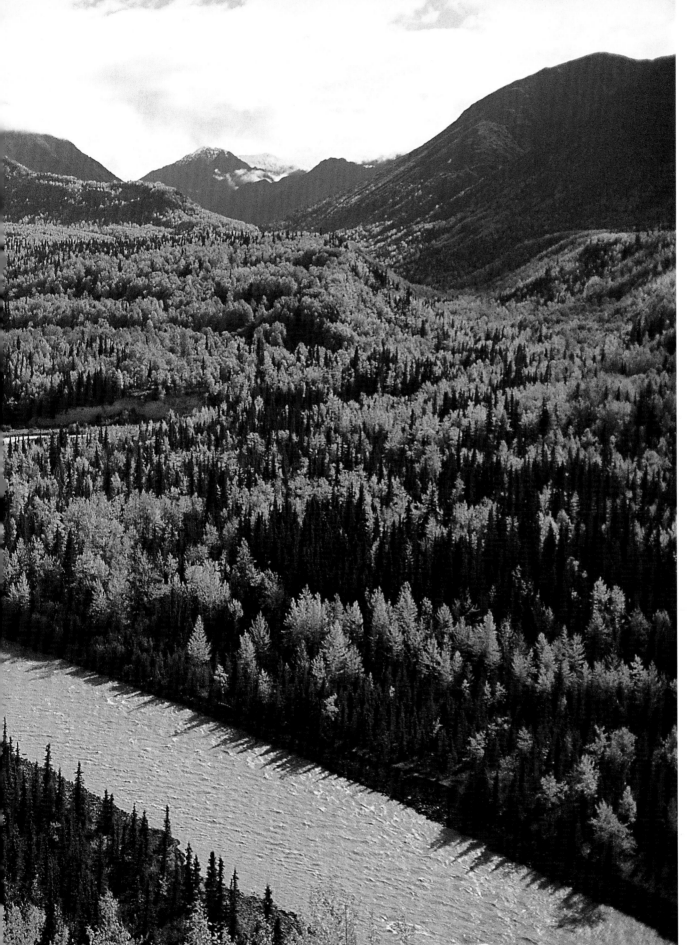

Meltwaters from the Talkeetna and Chugach Mountains swell the mighty Matanuska River. There are more than 3,000 rivers in Alaska and about 3 million lakes. Like over 99 percent of the state, most of these waterways are untouched by human development.

Home to half the population of Alaska, Anchorage is the state's largest city. The settlement was founded in 1915, when President Woodrow Wilson authorized the building of the Alaska Railroad. Workers and entrepreneurs arrived at the new base of operations, creating first a tent city and then a quickly growing community.

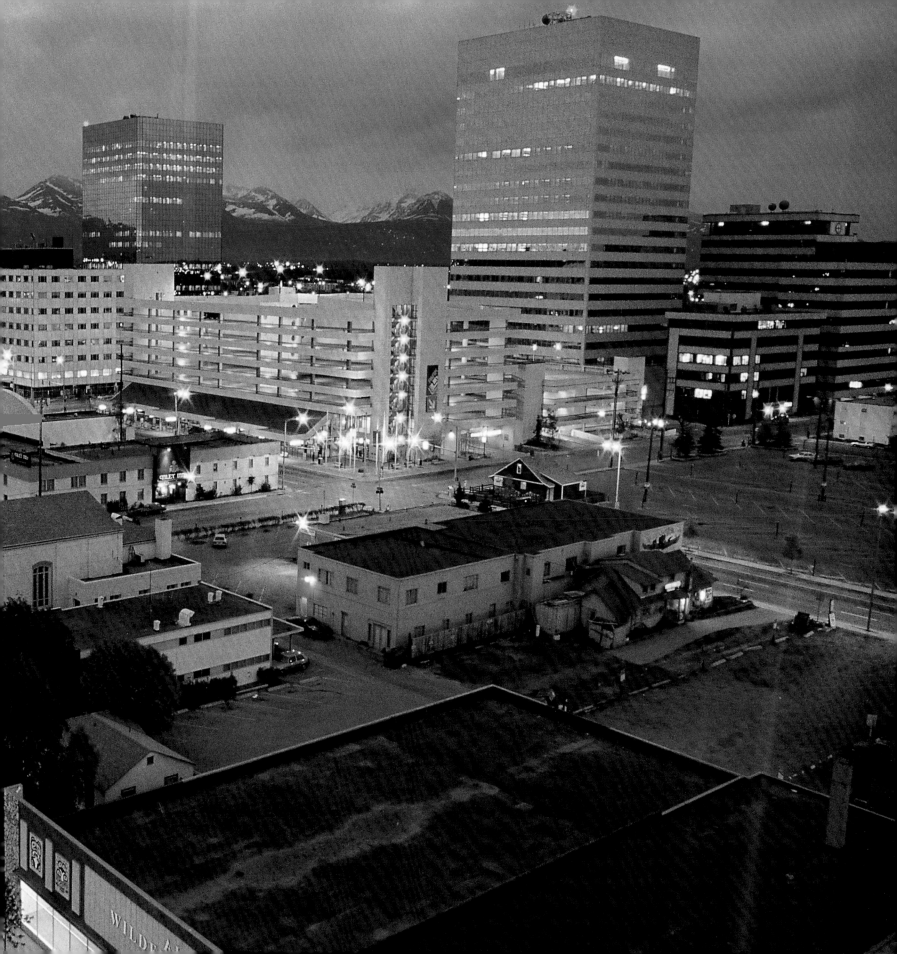

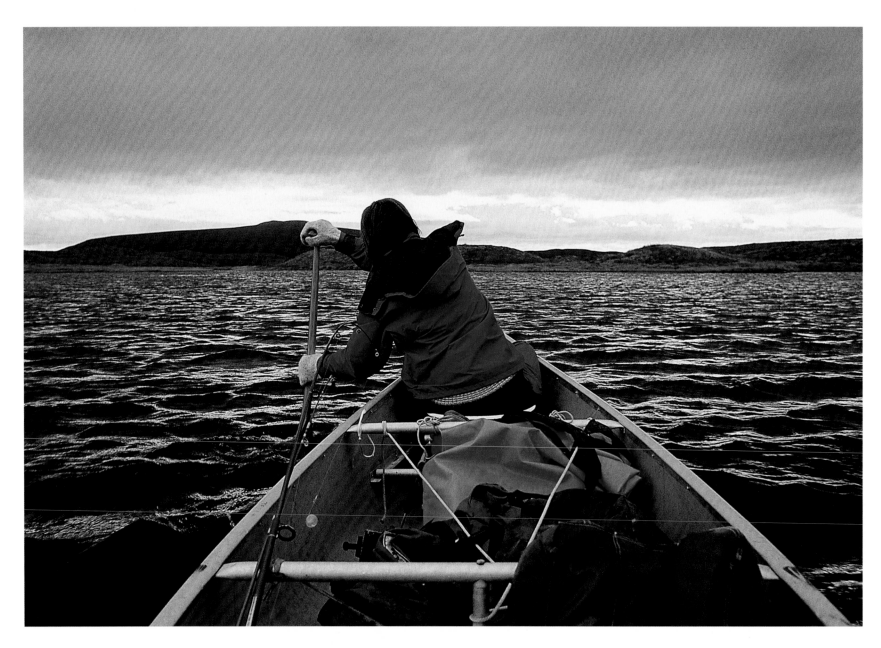

A popular canoe route leads adventurous paddlers on a 30-mile journey from the Tangle Lakes to the Delta River. More than one million people a year visit Alaska, but many explore only the southern coast and never see the vastly different terrain of the state's interior.

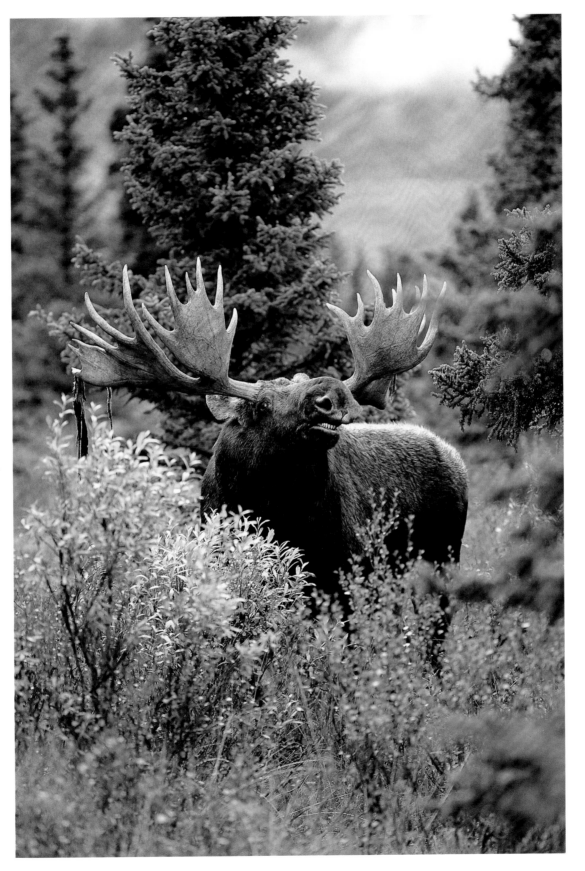

This bull moose is testing the air for signs of nearby females. Preferring to roam Alaska's wetlands and forests in solitude, these animals spend only a short time each year with a mate.

A visit to the traditional town of Nikolaevsk on the Kenai Peninsula may seem like a historic journey to Russia. Nikolaevsk was founded in 1968 by three families of Old Believers, a small sect of the Russian Orthodox church. There are now over 100 families in the community.

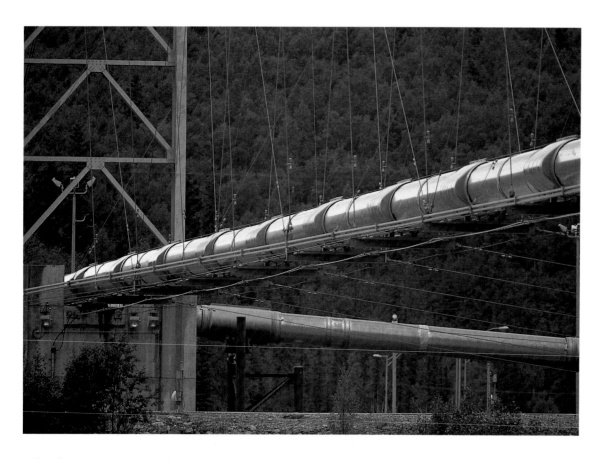

The largest oil pipeline in the world, the Trans-Alaska Pipeline traverses 800 miles on its route from the North Slope to the port of Valdez. At its peak production in 1988, the pipeline carred 2.1 million barrels per day.

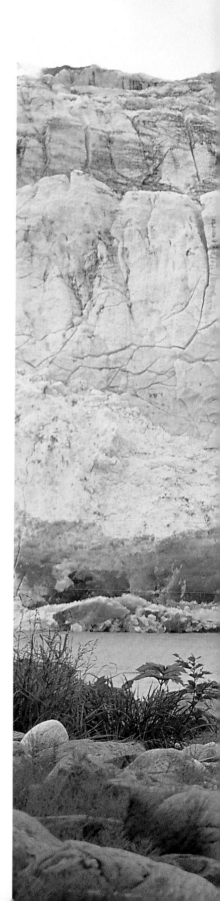

Visitors gather near the base of Childs Glacier, a 300-foot wall that regularly sends huge chunks of ice plummeting into the Copper River.

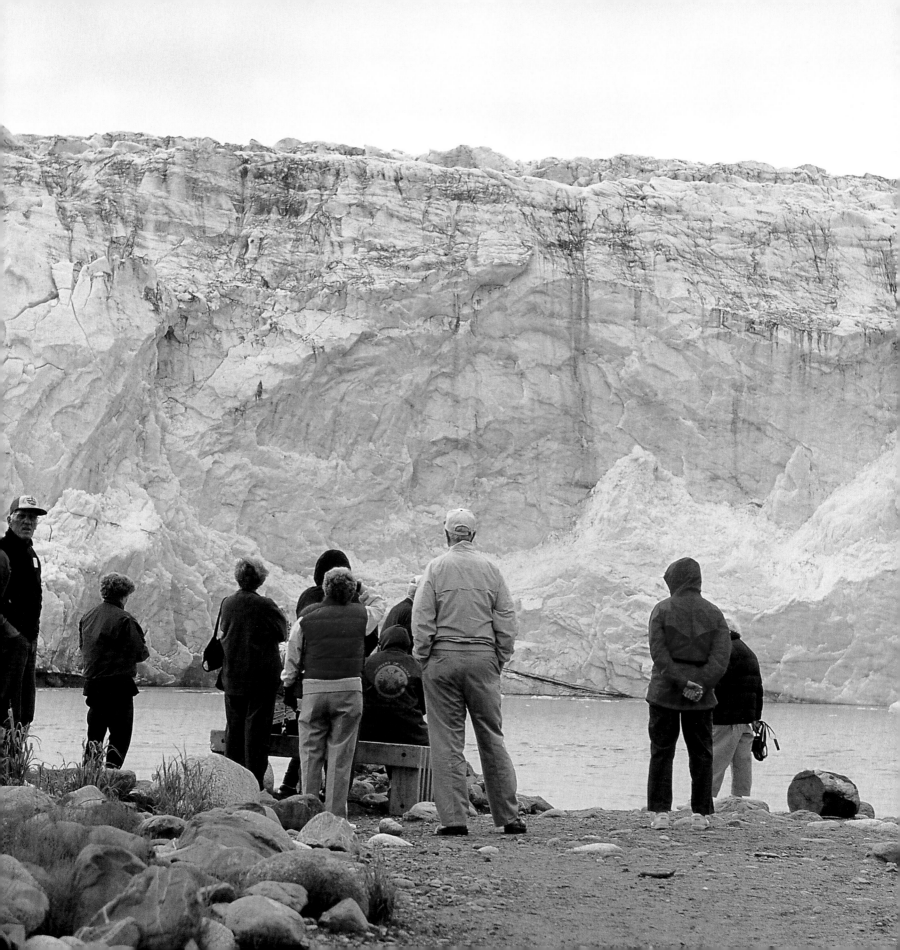

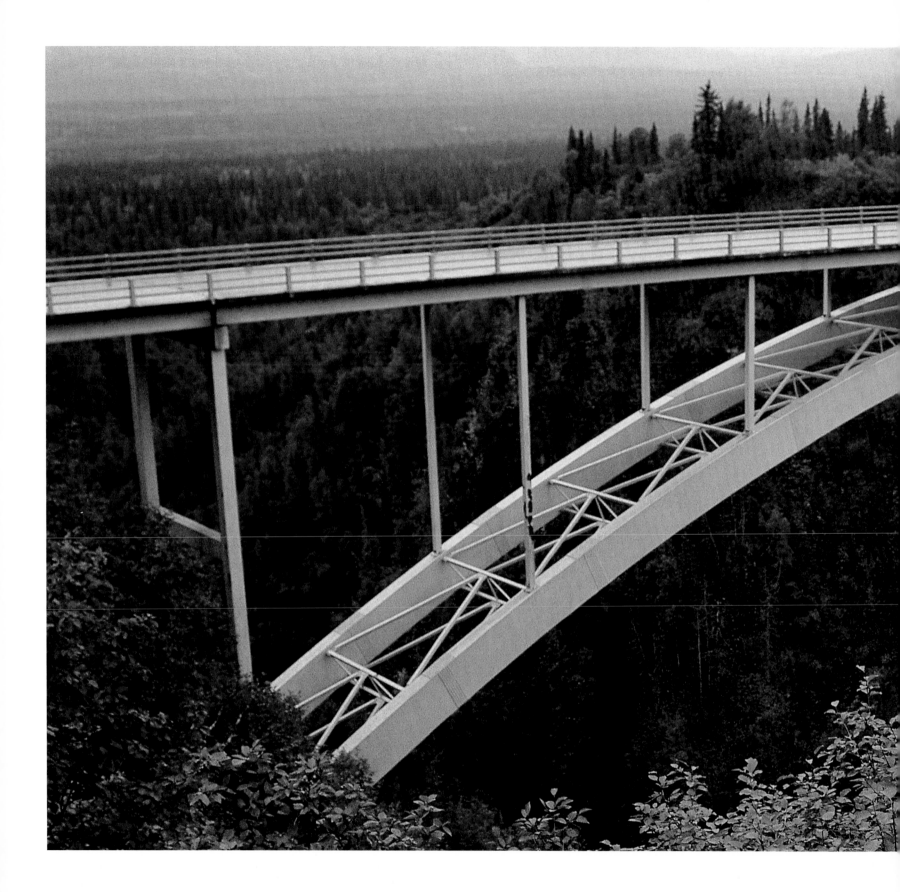

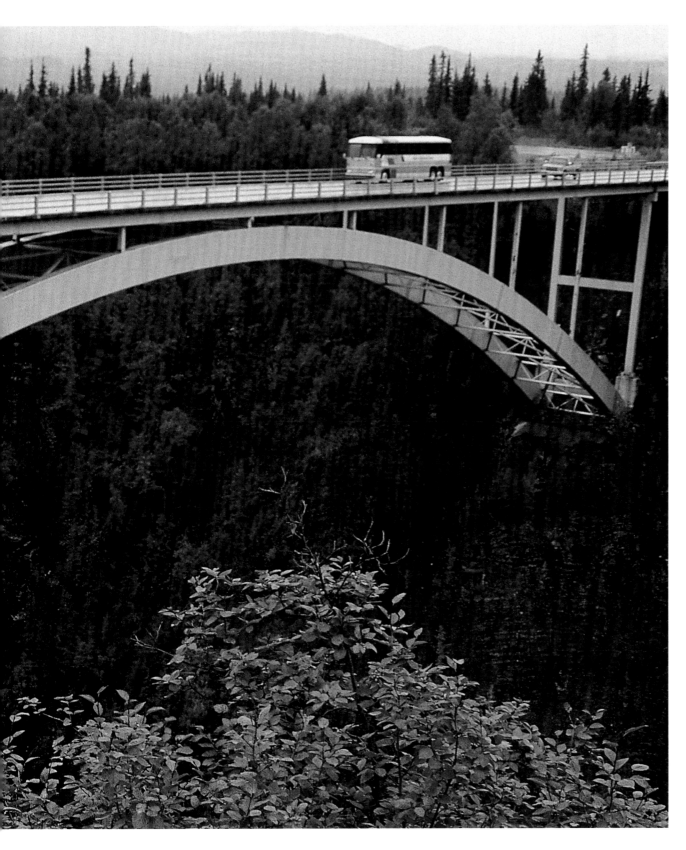

A massive bridge spans Hurricane Creek along the George Parks Highway between Fairbanks and Anchorage. The highway is named after an early 20th-century territorial governor, George Parks.

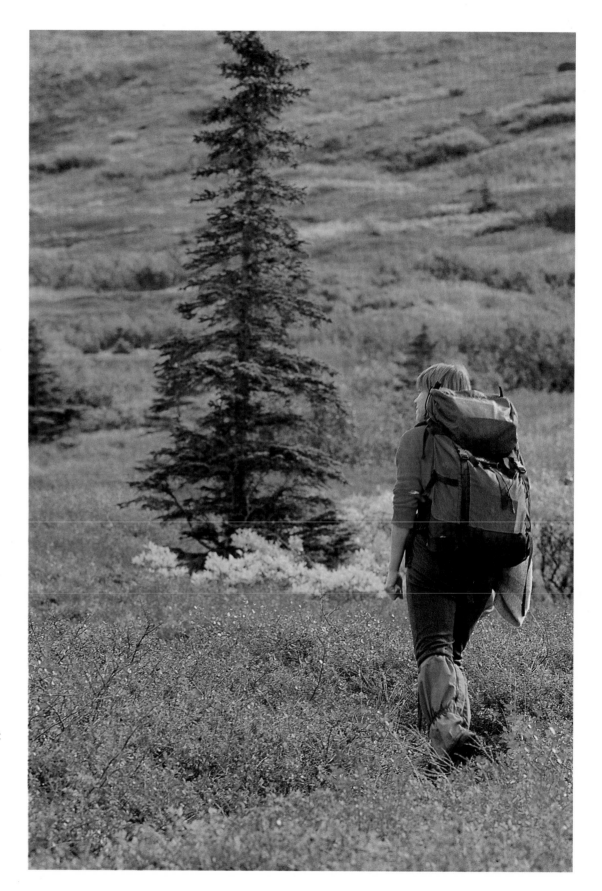

Denali National Park and the nearby Denali National Preserve protect about 6 million acres—an area larger than the state of Massachusetts. The pristine peaks and valleys in the region are home to more than 35 mammal and 150 bird species.

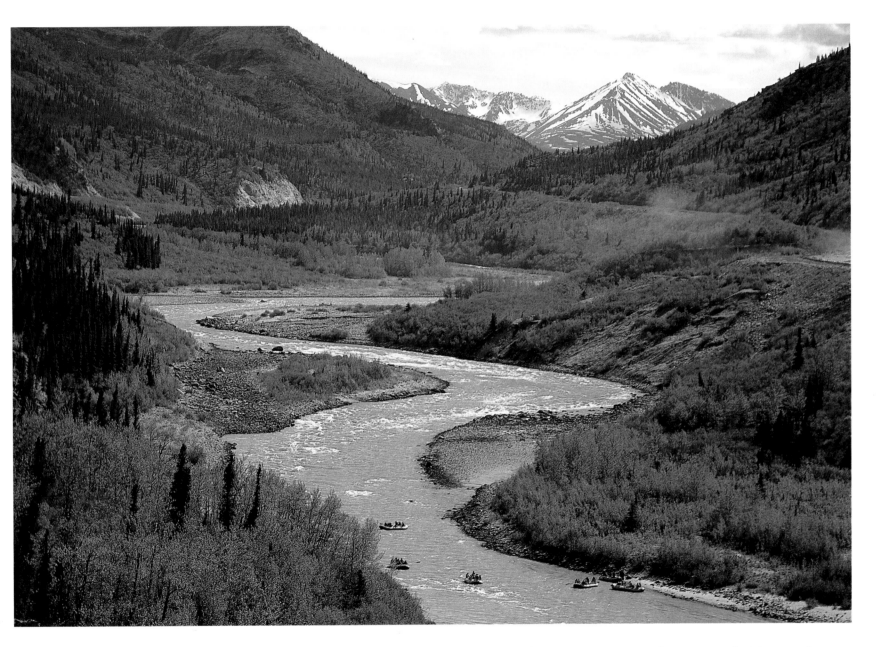

River rafters speed down the Nenana River from Denali National Park, following the waterway for about 20 miles until it reaches the George Parks Highway.

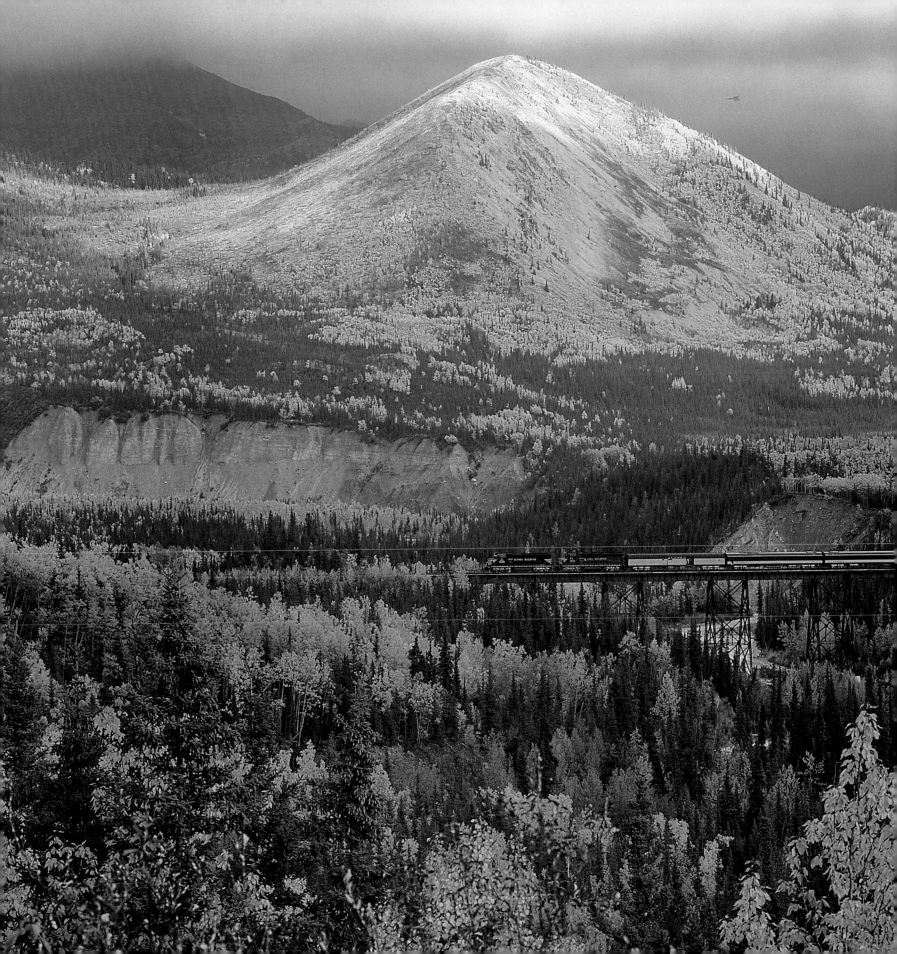

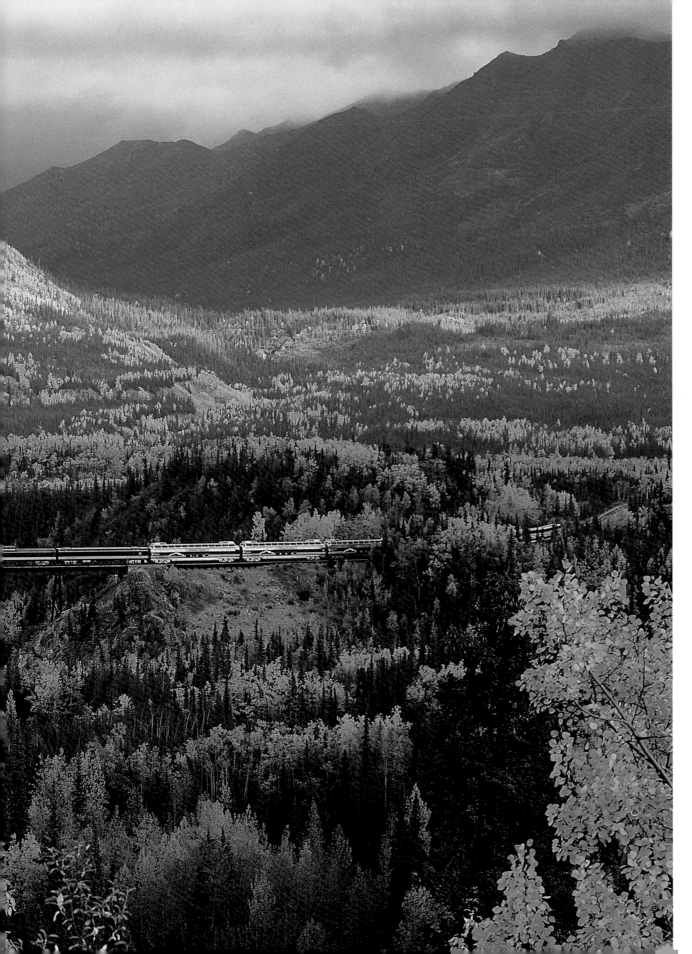

The Alaska Railroad negotiates a dizzying trestle bridge over Riley Creek in Denali National Park. The railway carries both freight and passengers through the park on its route from Anchorage to Fairbanks.

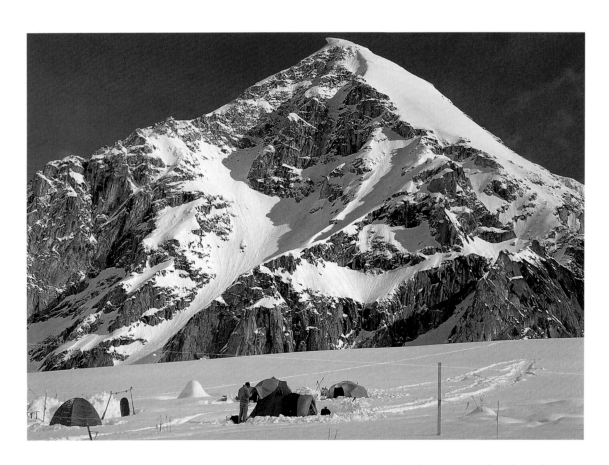

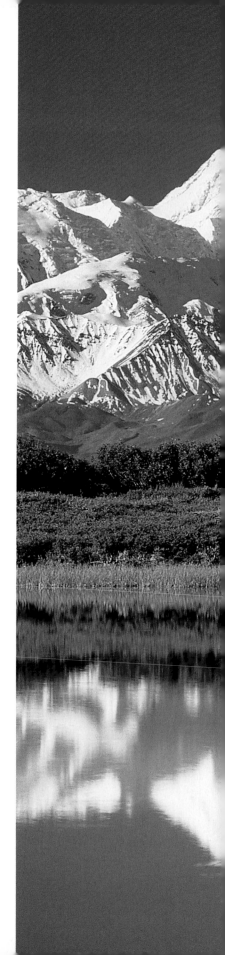

Mount McKinley was originally named Denali—"high one"—by local native people. Prospector William A. Dickey renamed it in honor of President William McKinley, although Alaskans still refer to the peak as Denali.

The highest mountain in North America, Mount McKinley towers 20,320 feet above sea level. It was first climbed in 1910 by a group of miners from Fairbanks who planted a 14-foot-flagpole to prove their success.

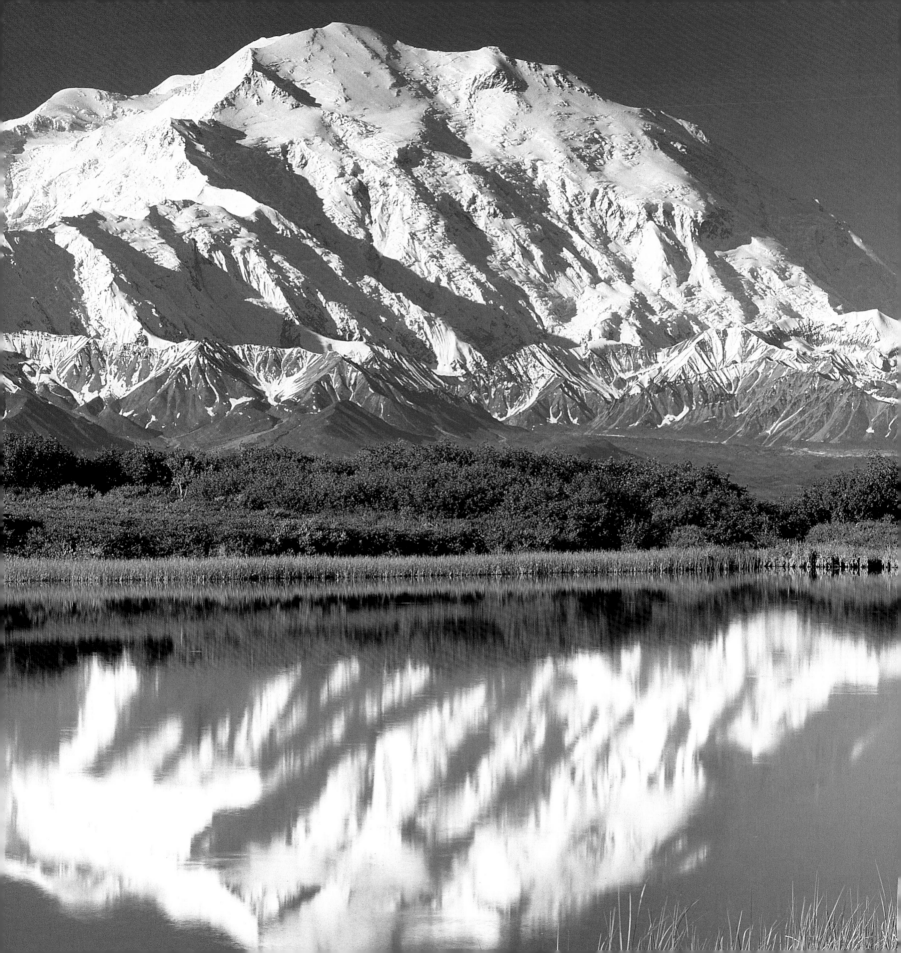

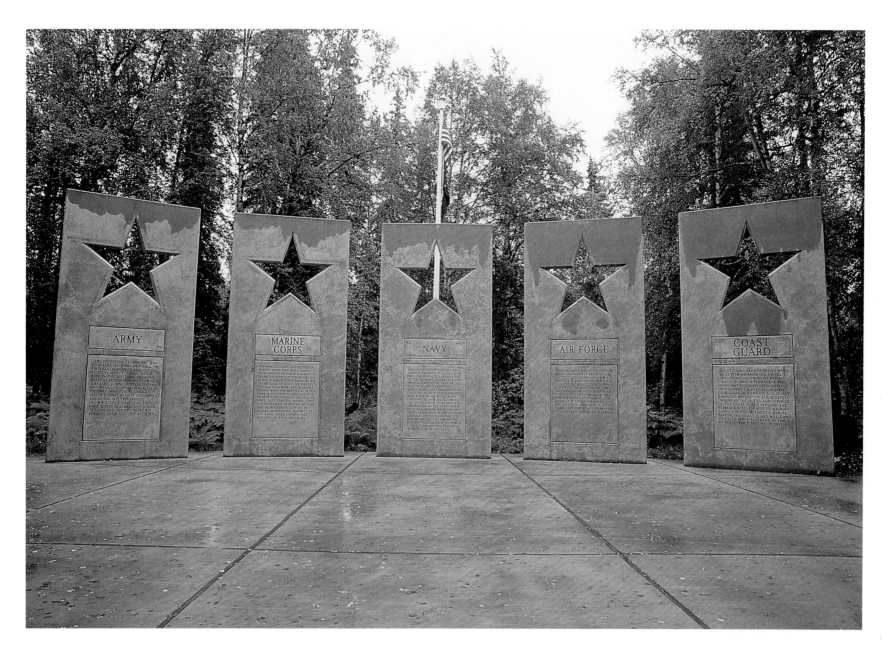

This tribute to Alaska's war veterans lies in Denali State Park, a 325,240-acre preserve adjacent to Denali National Park.

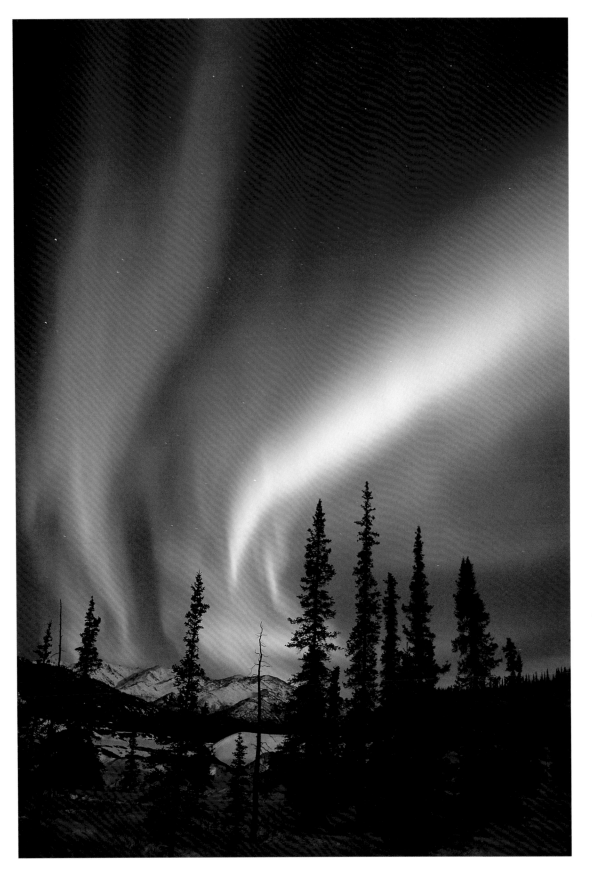

As solar winds encounter the magnetic fields above the North Pole, spectacular light displays—aurora borealis—spread across the sky. The northern lights are most common from August to May.

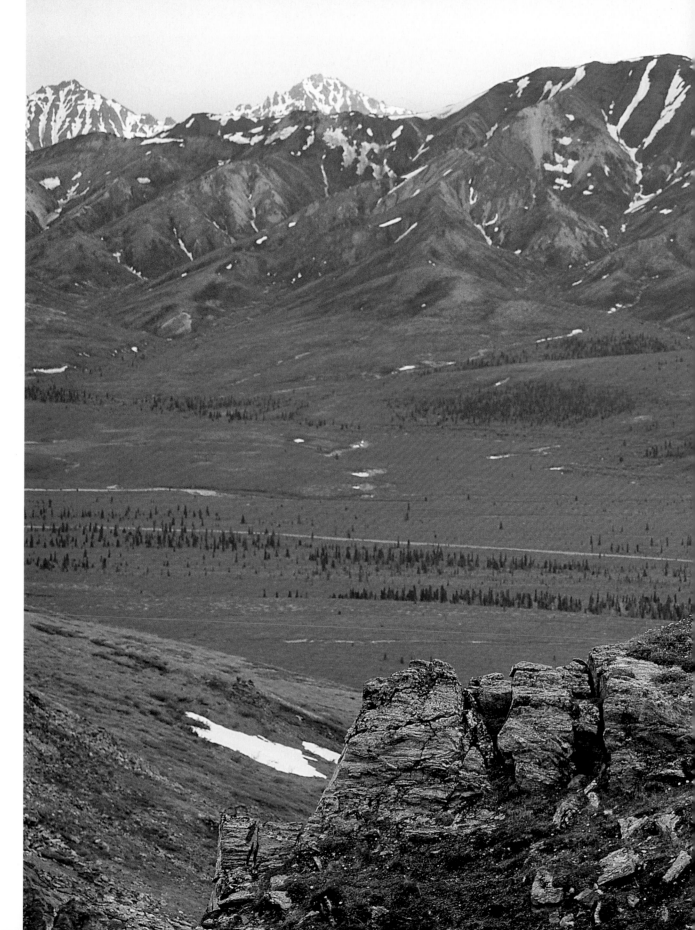

Dall sheep prefer steep cliffs and hill-sides where the terrain protects them from predators. In small herds, however, they will venture onto Alaska's tundra in search of better grazing.

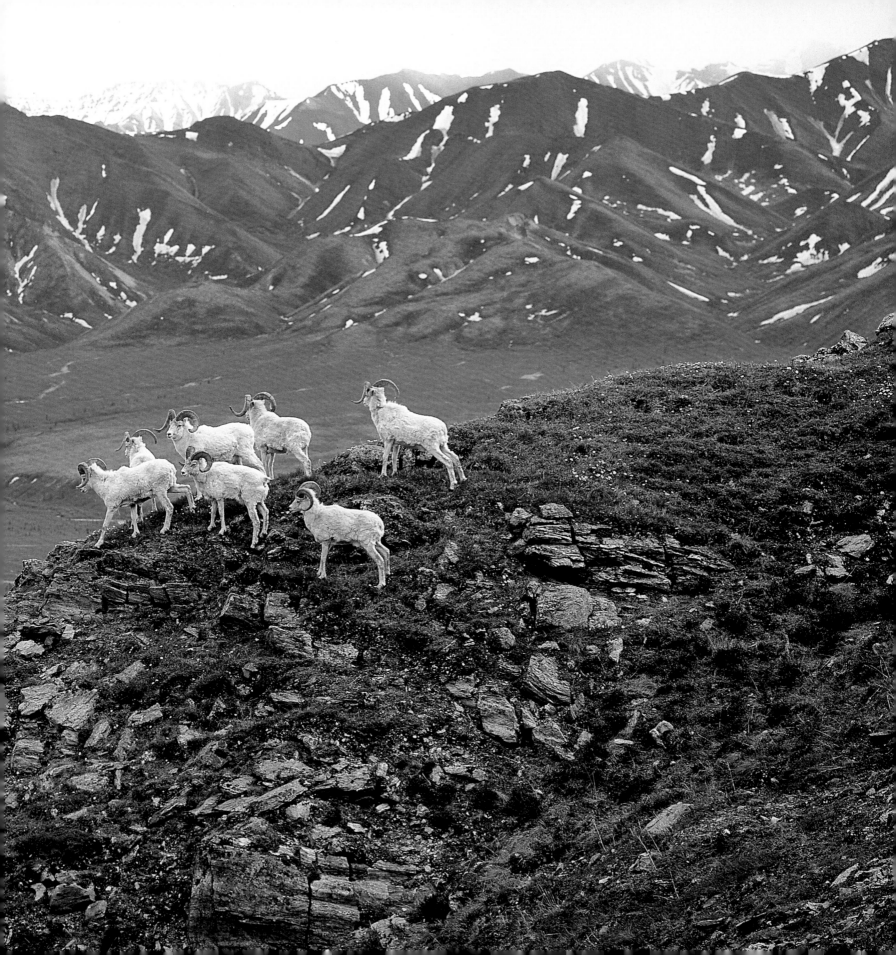

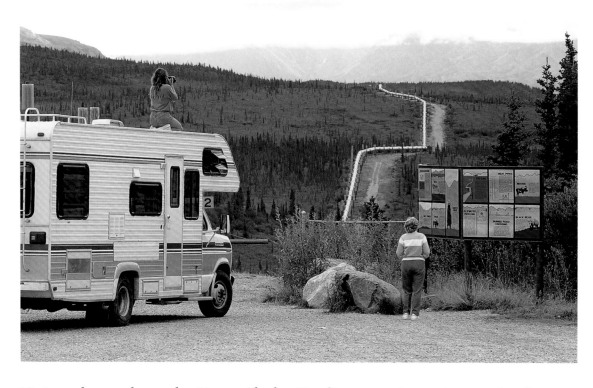

Visitors learn about the Trans-Alaska Pipeline at a viewpoint south of Fairbanks. The 800-mile structure, finished in June, 1977, took more than three years to complete and cost about $8 billion.

This sod-roofed cabin was probably once home to a trapper or prospector. Adventurers who arrived in Alaska a century ago found a wild and sparsely inhabited land. Even today, there is on average only about one person per square mile.

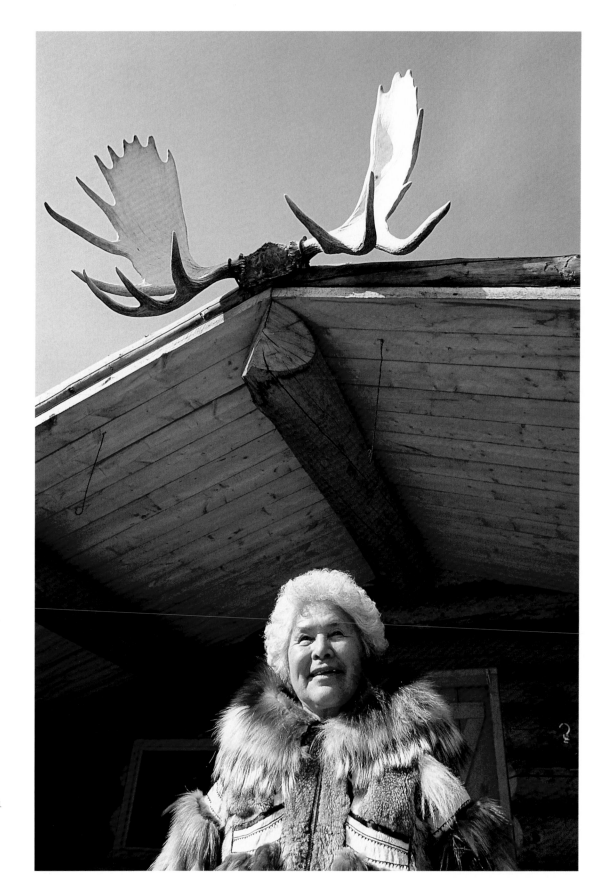

Sophisticated trapping methods and abundant game, fish, and berries allowed native people to thrive here for thousands of years before the arrival of American and European explorers and prospectors.

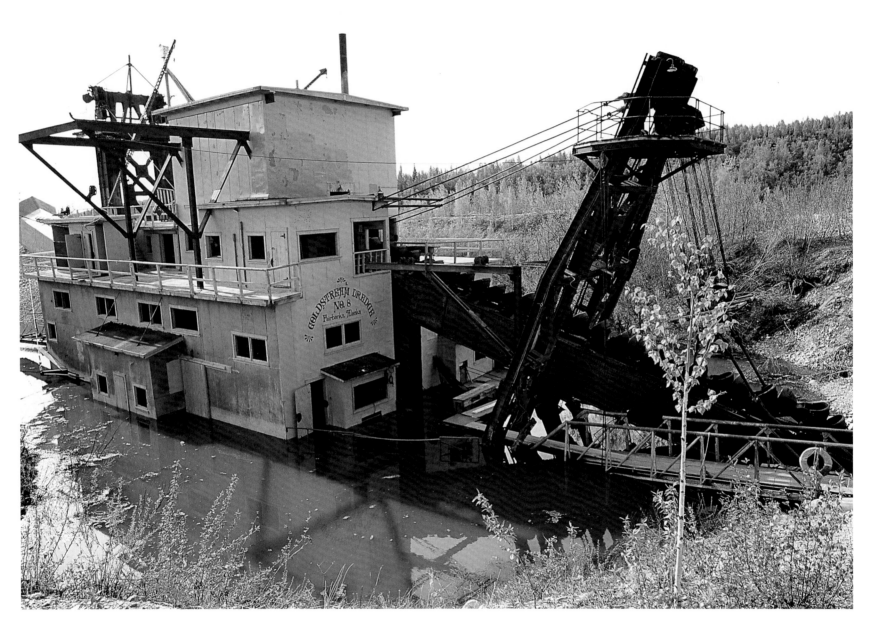

Gold Dredge #8 began operating near Fairbanks in 1928 and produced
7.5 million ounces of gold over the following three decades. It is now a
national historic site, a national historic mechanical engineering landmark,
and one of the area's most popular tourist attractions.

Fairbanks was founded in 1901 as a trading and supply base for gold miners. It grew when it became the northern terminus of the Alaska Railroad, then a base for the construction of the Trans-Alaska Pipeline.

This narrow-gauge track leads to a reconstructed gold mine, where travelers learn the methods used by prospectors more than a century ago.

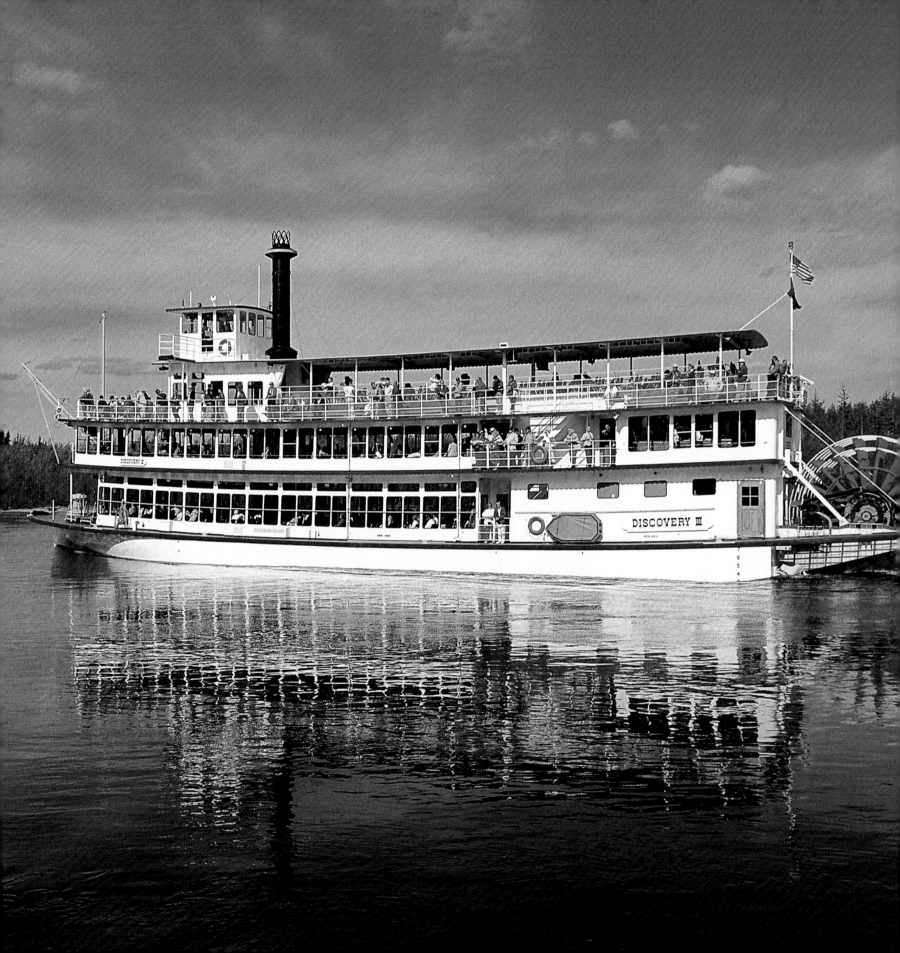

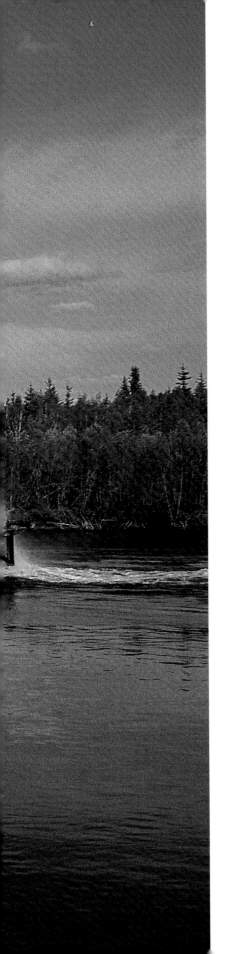

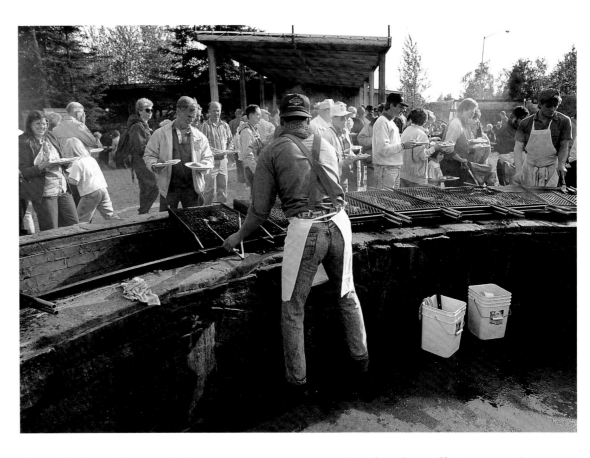

The Alaska Salmon Bake is an institution in Fairbanks, offering residents and visitors a feast of local salmon and halibut, steak and ribs.

In the wake of the vessels that plied this route during the gold rush, the riverboat *Discovery* carries more than 900 passengers on a journey to a native fishing camp, sled dog demonstrations, and spectacular shoreline scenery.

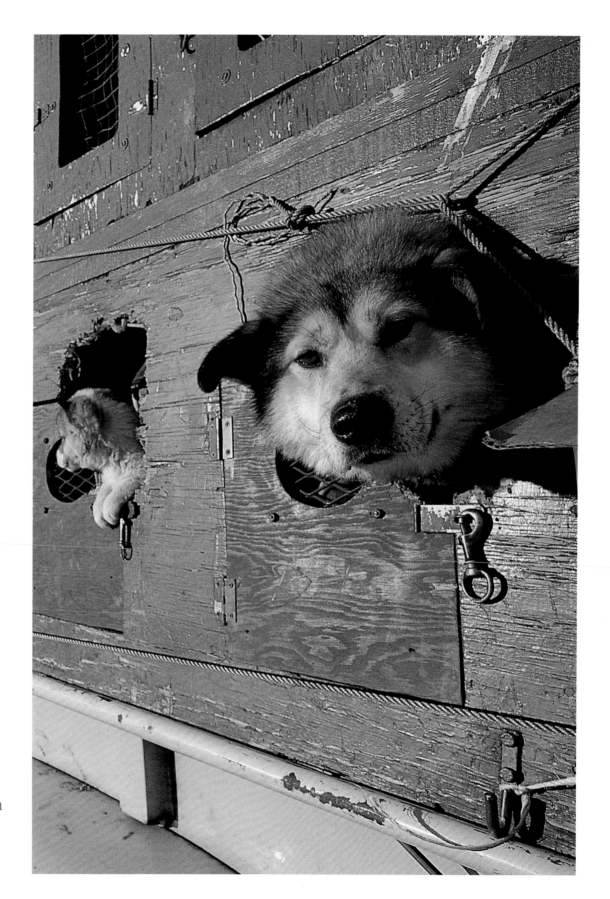

Teams from across the continent travel to Alaska to compete in sled dog races, from community-based events to the world-famous Iditarod and Yukon Quest International races.

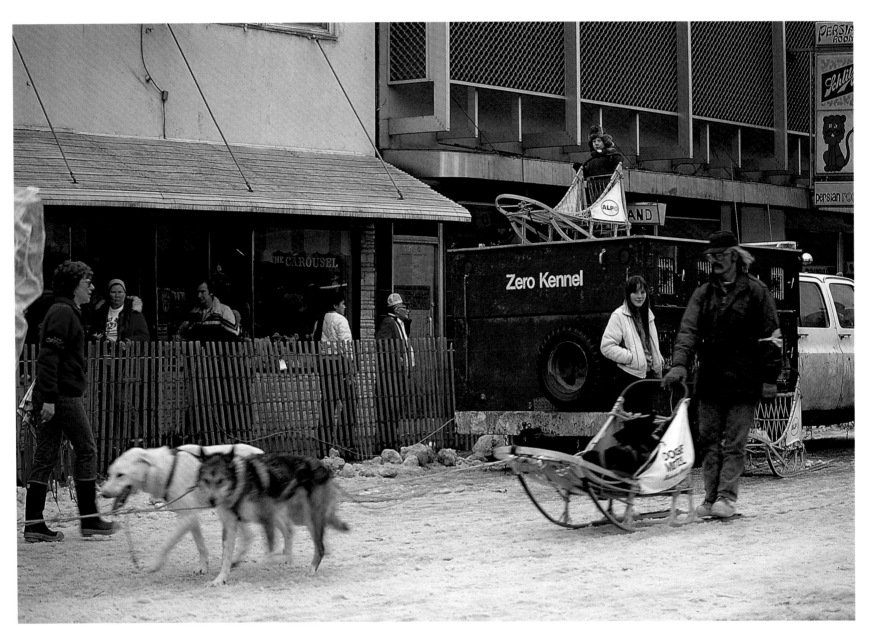

Hardy souls gather with their dog teams in Fairbanks each February for the grueling 1,000-mile Yukon Quest International Sled Dog Race from Fairbanks to Whitehorse, Canada. The race takes 10 to 12 days and leads teams through some of the toughest terrain on earth.

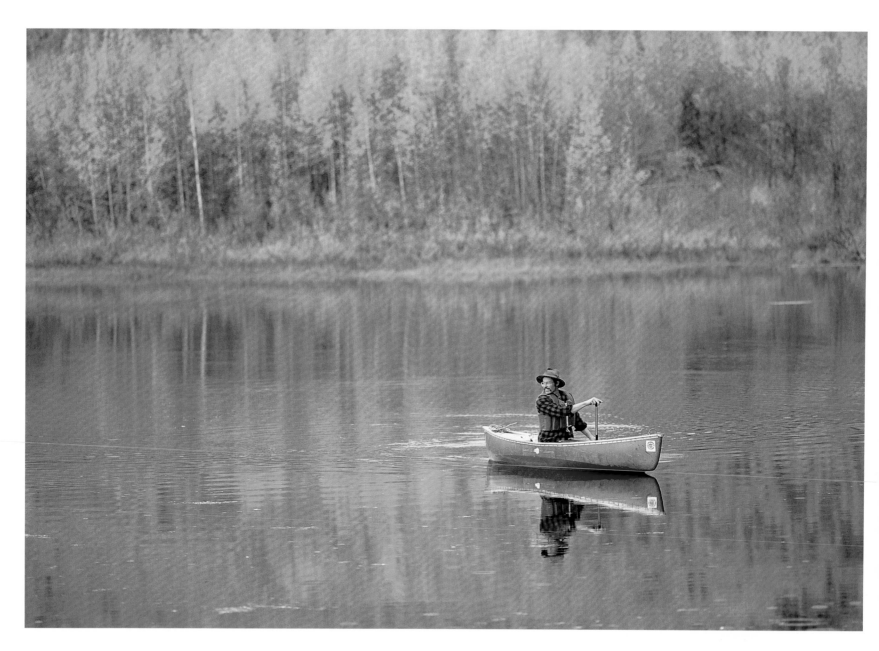

Swelled by meltwater, this tributary empties into the Chena River,
which in turn empties into the Tanana. The ghost town of Chena,
destroyed by a flood in the 1950s, stands nearby.

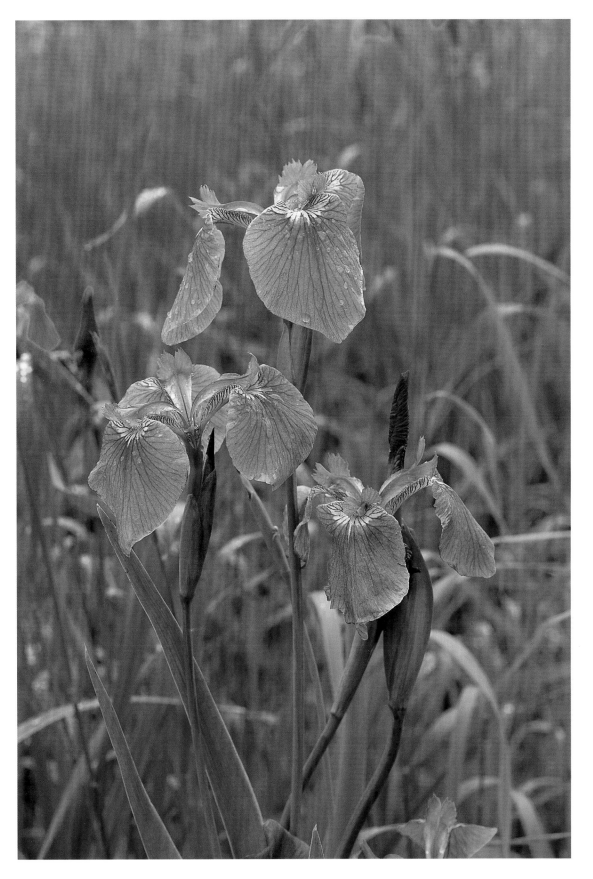

This vibrant species of wild iris blooms in midsummer in diverse regions, from the hillsides of Alaska to northern Canada, Japan, and China. Its flowers, less than an inch across, range from purple to white.

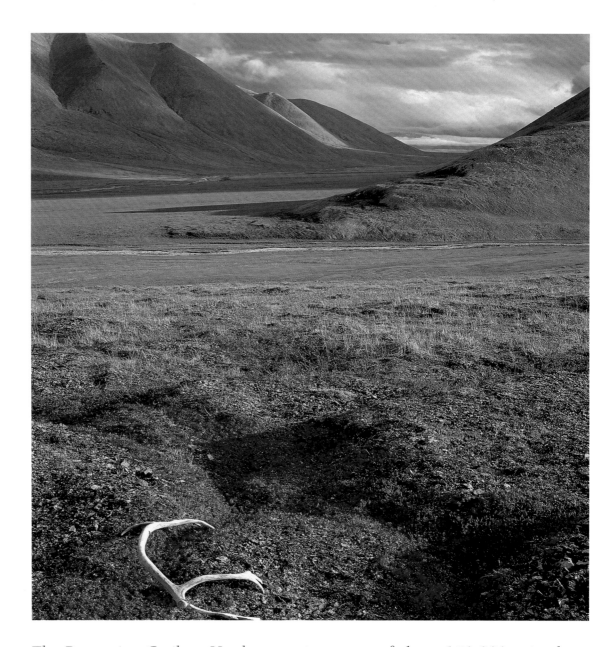

The Porcupine Caribou Herd, a massive group of about 150,000 animals, migrates between Alaska's Arctic National Wildlife Refuge, where they calve, and Ivvavik National Park in Canada's Yukon Territory.

Within the Arctic Circle, the Arctic National Wildlife Refuge is carpeted by snow for nine months of the year. This preserve is home to more than 140 migrating bird species, caribou, Dall sheep, wolves, polar bears, and grizzlies.

A crescent moon highlights
the coastal plain, part of
the Arctic National Wildlife
Refuge. Debate over oil
exploration here continues.
The issue pits oil compa-
nies, who argue that huge
reserves can be extracted
while damaging only a
small portion of the refuge,
against environmentalists
and native groups, who call
for complete protection of
the land and wildlife.

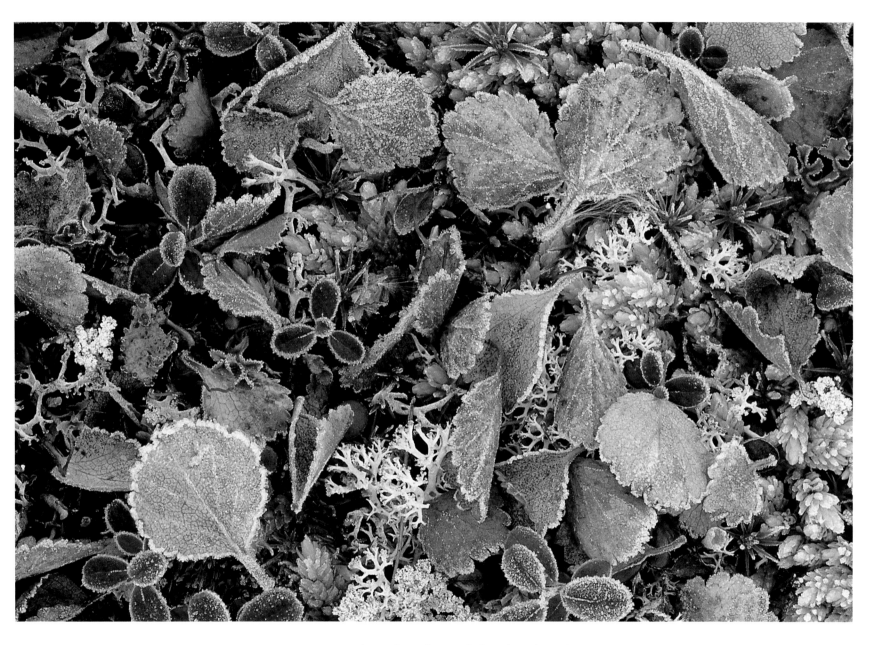

Only a few feet of this land melts in the summer; the remainder is frozen throughout the year. The plants that survive on the tundra grow incredibly slowly—300-year-old spruce trees and 100-year-old willows are the size of small shrubs.

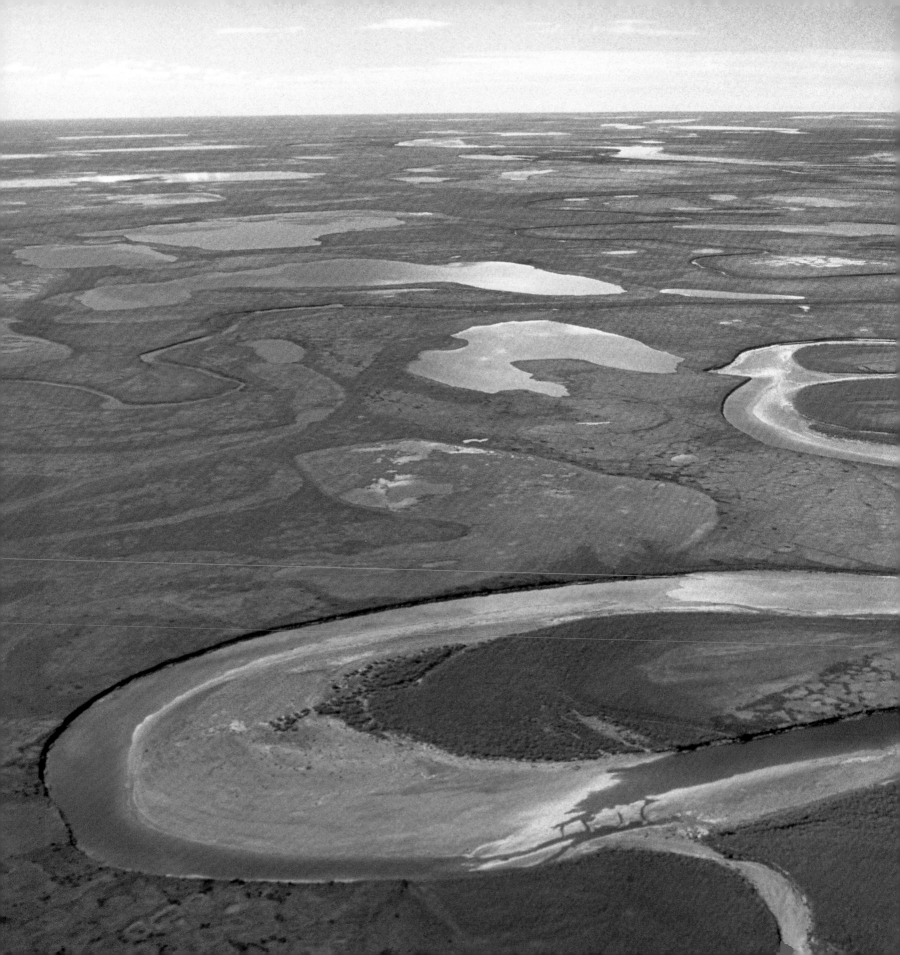

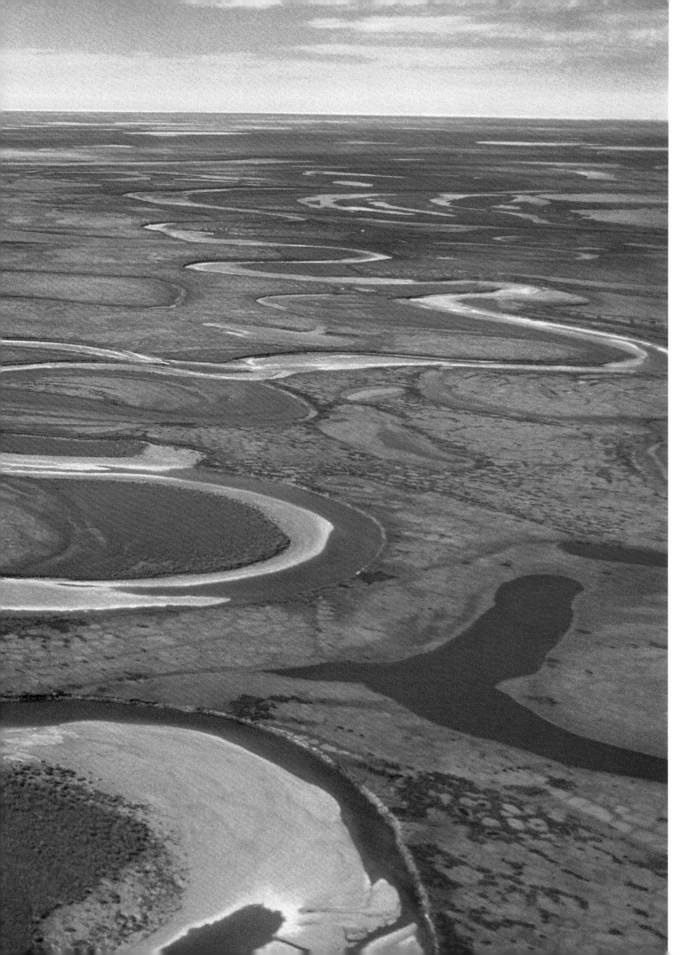

The geographic diversity of Alaska's north, from the steep slopes of the Brooks Range to coastal deltas and lagoons, is part of what makes the region so rich in wildlife. The Arctic National Wildlife Refuge protects more plant and animal species than any other northern preserve.

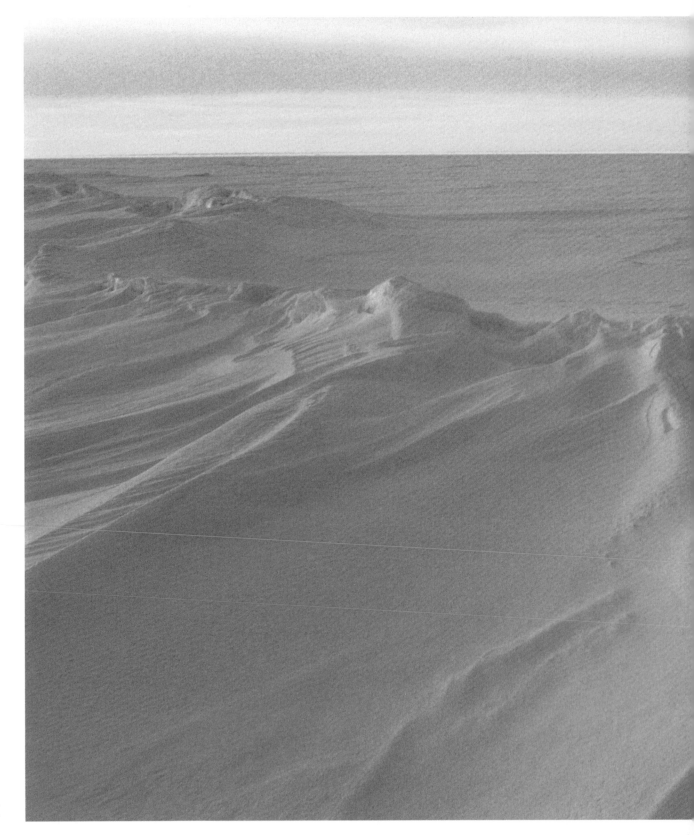

Average temperatures in Alaska's northern Arctic region drop to −20°F in the winter months, when the sun remains constantly below the horizon. In summer, when the sun never completely sets, temperatures rise to 47°F.

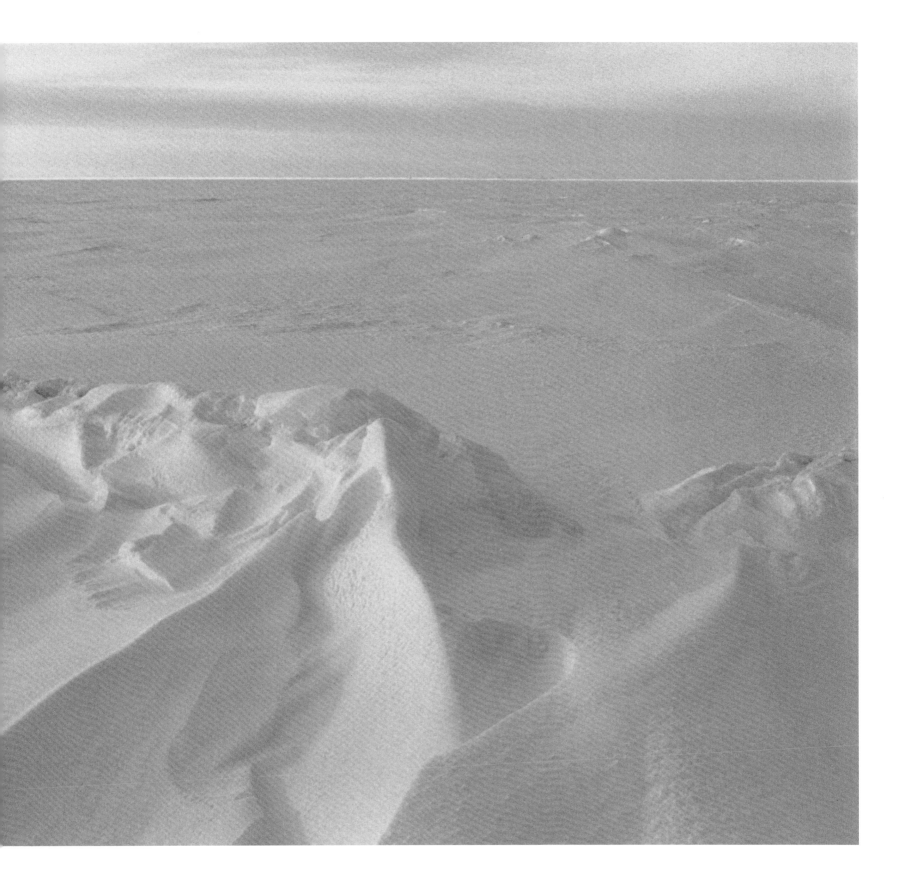

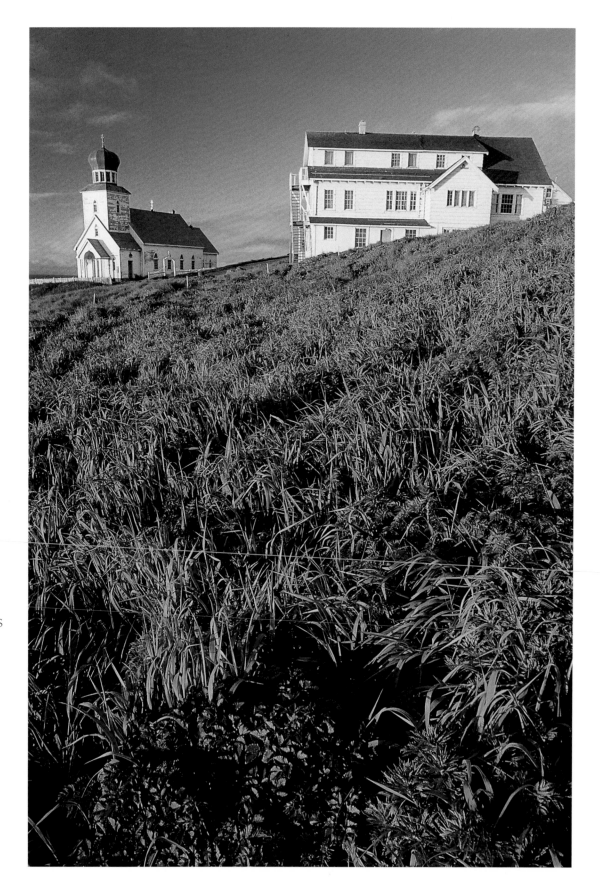

The 200 human inhabitants of St. George, a tiny island in the Bering Sea, are far outnumbered by seabirds and marine life. Over 210 avian species nest on the cliffs and tundra here each summer, and more than a million fur seals gather on the beaches.

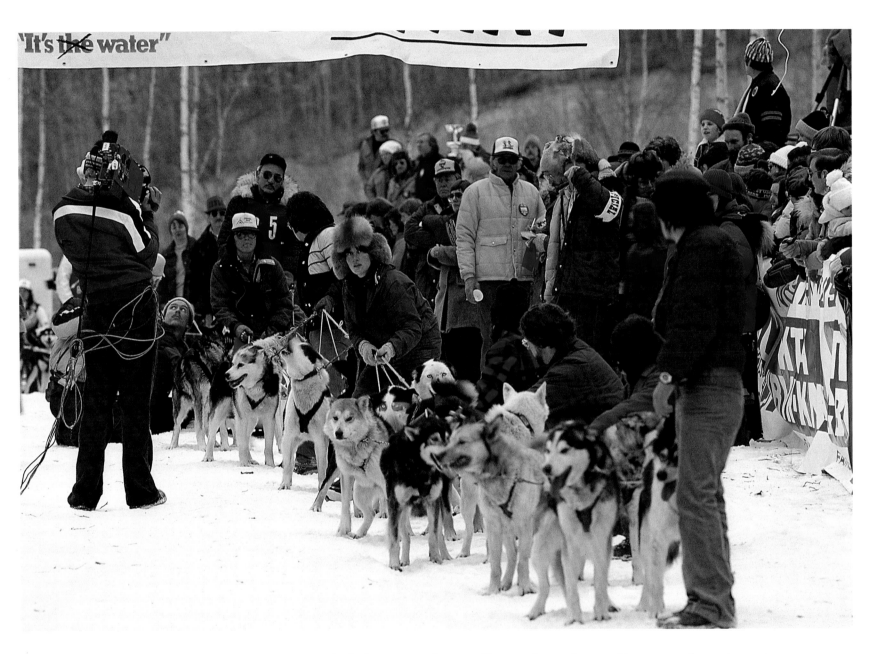

Sled dogs, used to pull people and supplies over the winter ice, were once an everyday part of Alaskan life. Today, sled dog racing has grown into a recreational pastime and the Iditarod, a journey of 1,049 miles from Anchorage to Nome, is known as the Olympics of the sport.

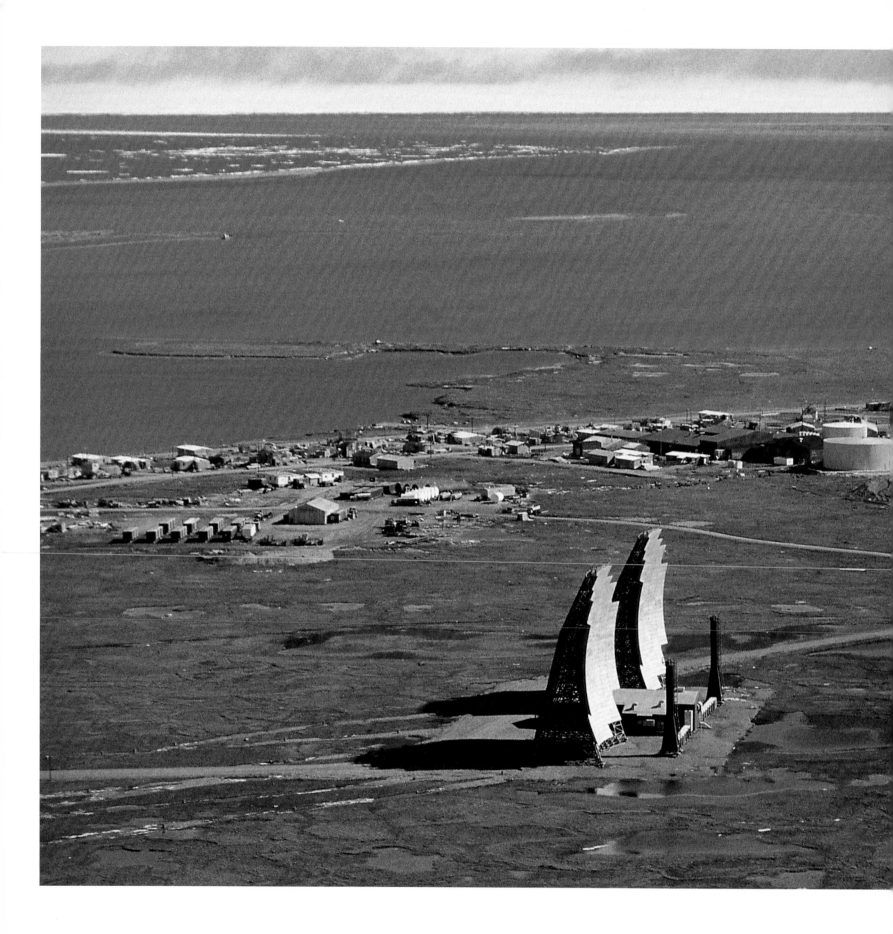

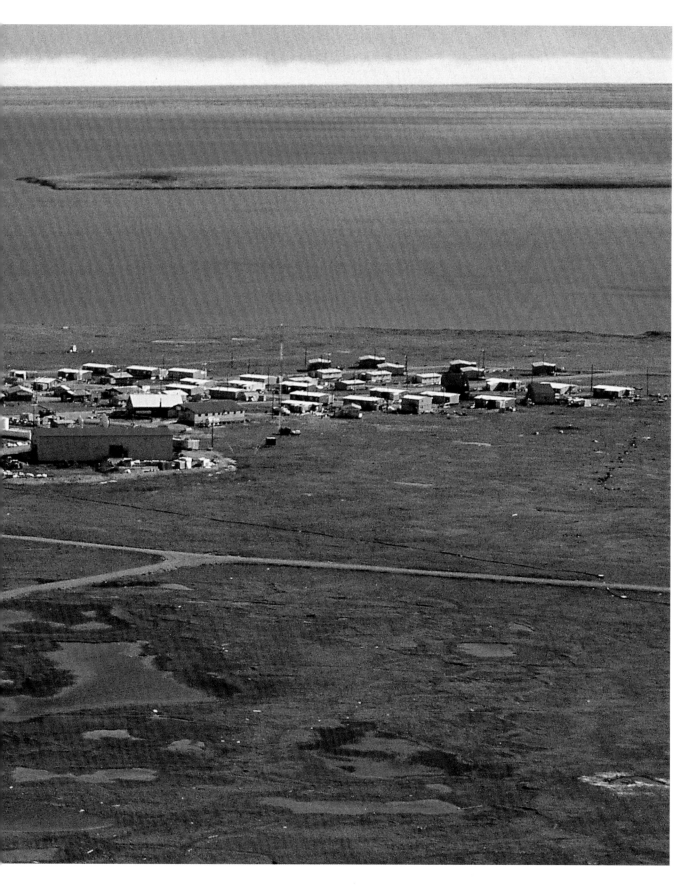

More than a century ago, Barter Island was a stopping point for commercial whaling ships. Now, the island's tiny village of Kaktovik, the only permanent settlement within the Arctic National Wildlife Refuge, is home to a climate research center and an airport.

On October 18, 1867, William H. Seward, acting on behalf of the United States, bought Alaska from Russia for $7,200,000—about two cents an acre. At the time, the purchase was dubbed "Seward's Icebox." But the enormous natural resources offered by the new territory soon proved the purchase very worthwhile.

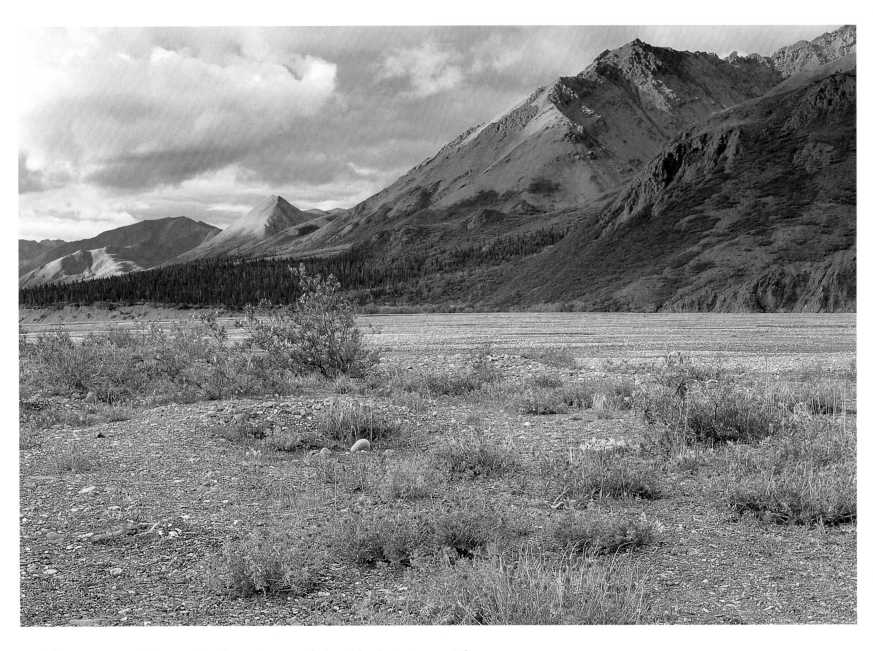

Wild sweet peas bloom in the valleys of the Alaska Range. There are more than 150 species of this plant in the world, many with small, strongly scented flowers.

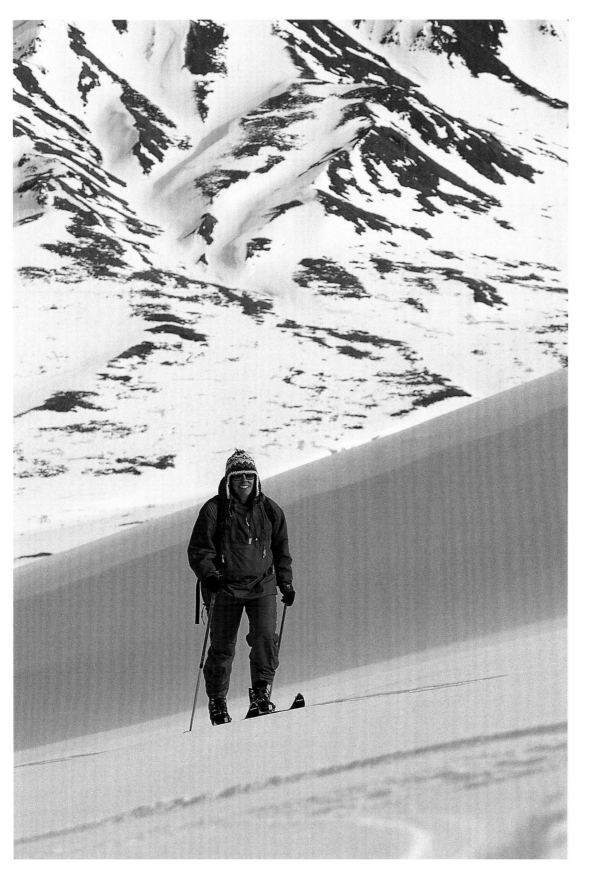

Tourism began to increase in Alaska when the Alaska Highway opened in 1948, followed by the Alaska Marine Highway System in 1963. Hundreds of guides and outfitters now make their livings leading visitors on unique backcountry adventures.

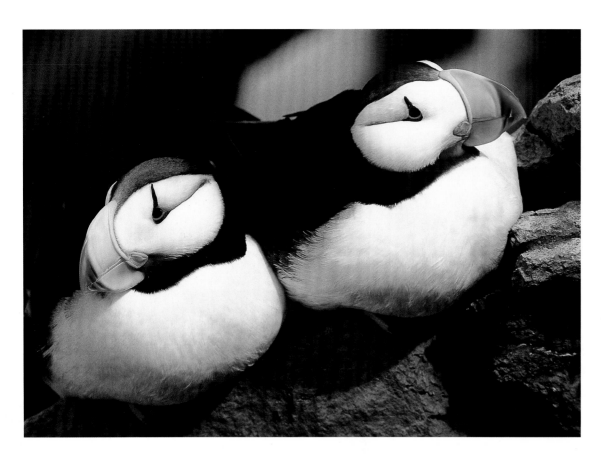

Horned puffins find protection from predators on the promontories of Alaska's islands. Many of these birds return with their mates to the same nesting places each year, signalling their neighbors with their bright bills.

Thousands of walruses arrive at Round Island each spring to laze on the shores and feed on shellfish and invertebrates in the coastal waters. This island is one of seven in Walrus Islands State Game Sanctuary.

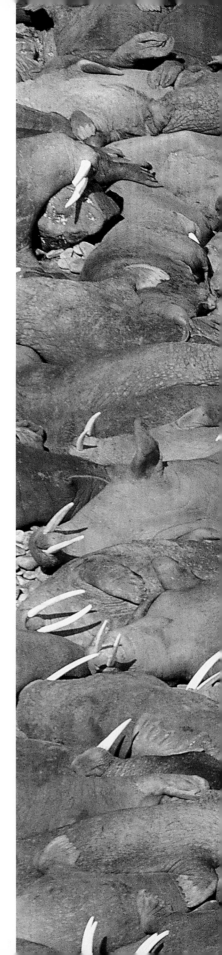

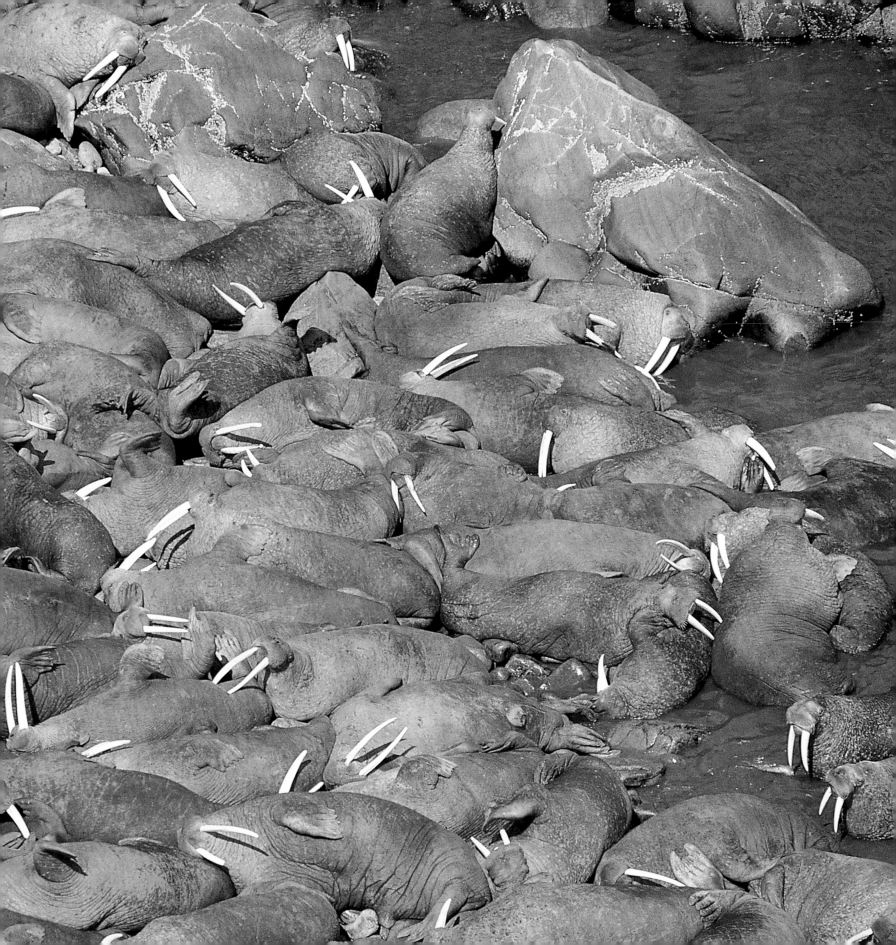

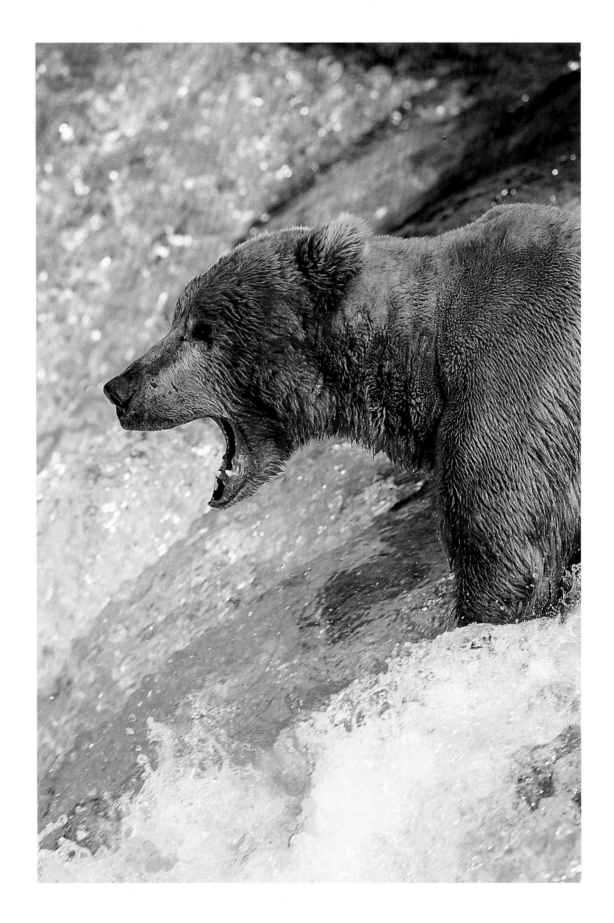

McNeil River State Game Sanctuary has one of the world's largest concentrations of brown bears in their natural habitat. Normally solitary, about 40 grizzlies congregate along the river each summer, gorging on the spawning salmon.

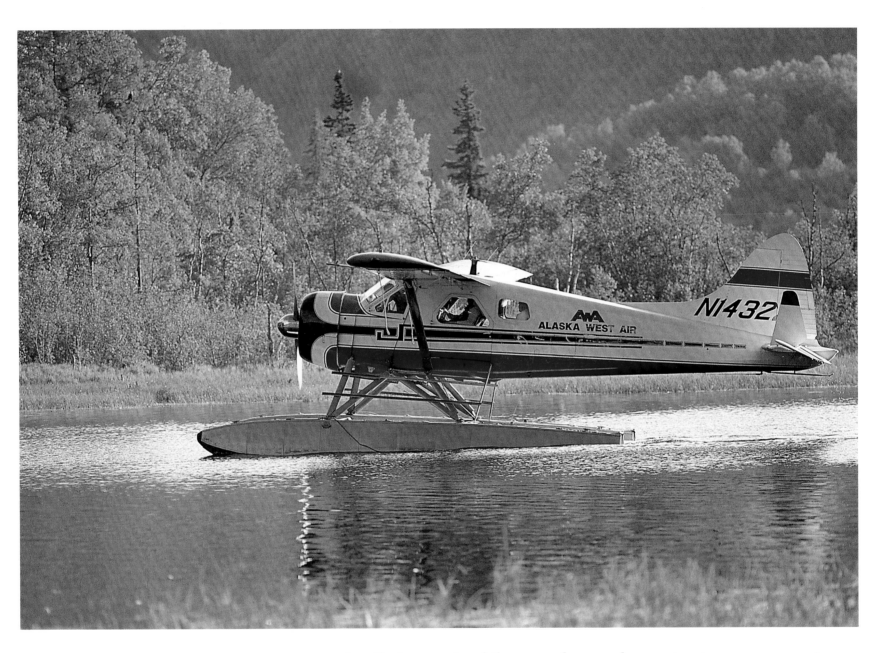

Small planes wing hikers, anglers, and canoeists into remote regions, from the scenic lakes of the Alaska Range to the rivers of the north.

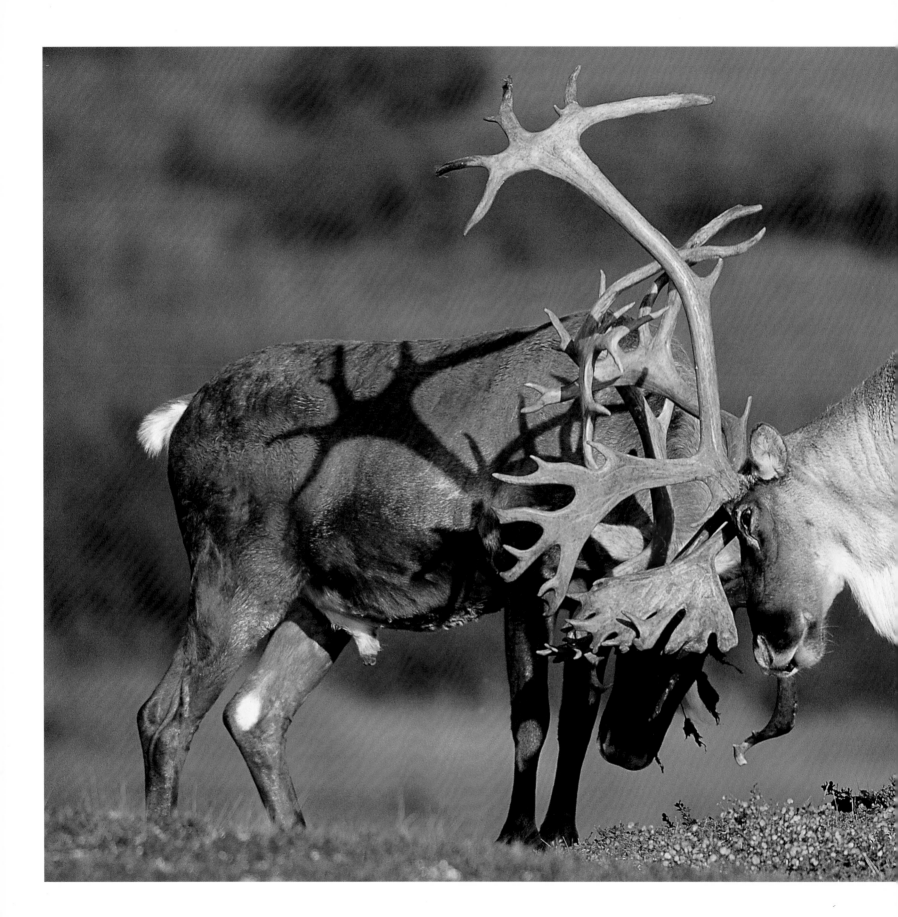

Included in America's national park system because of its rich wildlife population, untouched rivers, and pristine wilderness, Gates of the Arctic National Park and Preserve draws about 4,000 visitors each year. Most of these are experienced back-country travelers, who arrive to challenge the harsh terrain and view the area's diverse wildlife.

Photo Credits